PAPER MARBLING
LEARN IN A WEEKEND

First published in the United Kingdom in 2024
by Skittledog, an imprint of Thames & Hudson Ltd,
181A High Holborn, London WC1V 7QX

British Library Cataloguing-in-Publication Data
A catalogue record for this book is available from
the British Library

ISBN 978-1-837-76033-6

Printed and bound in China by C&C Offset Printing Co., Ltd

Senior Editor: Virginia Brehaut
Photographer: Charles Emerson
Designer: Masumi Briozzo
Production: Felicity Awdry

Additional photography: pages 35, 36, 37, 75, 76
by Natascha Maksimovic and page 77 by Jo Bridges

Be the first to know about our new releases, exclusive
content and author events by visiting:

skittledog.com
thamesandhudson.com
thamesandhudsonusa.com
thamesandhudson.com.au

PAPER MARBLING
LEARN IN A WEEKEND

NATASCHA MAKSIMOVIC

Skittledog

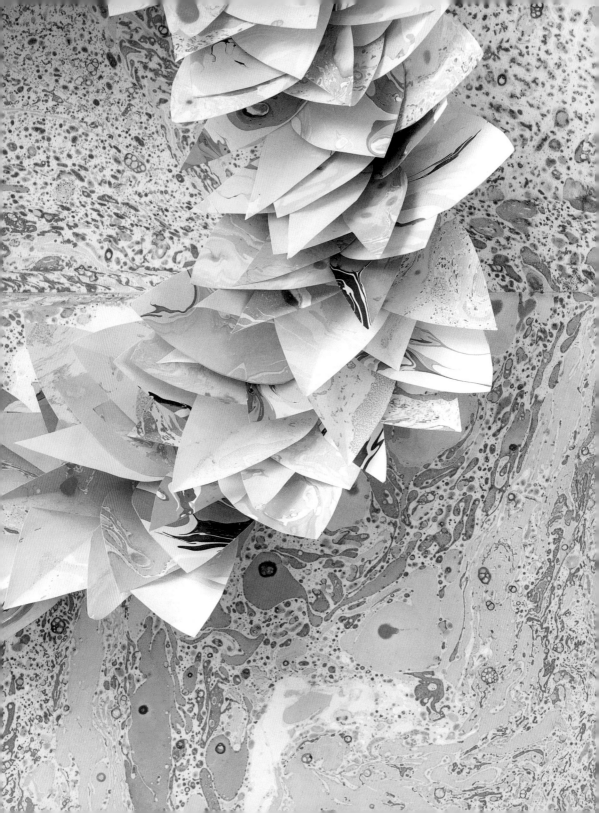

CONTENTS

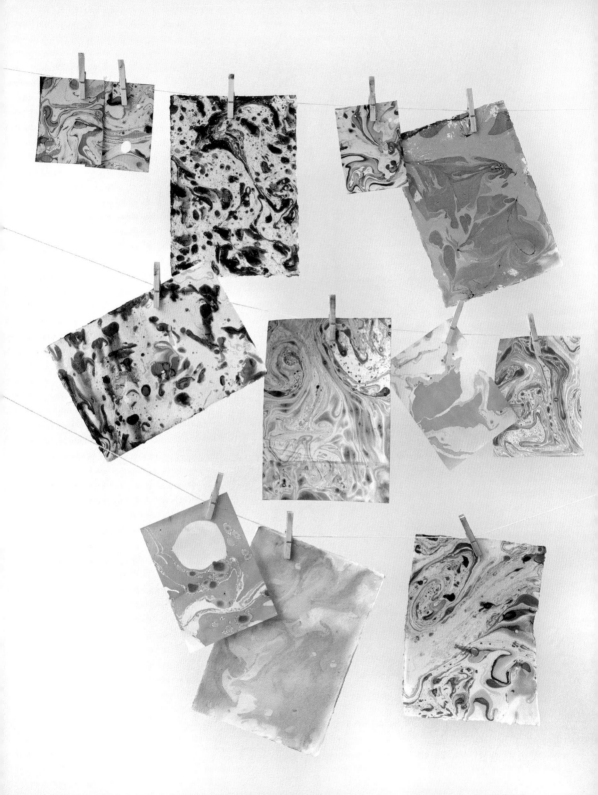

INTRODUCTION

The type of paper marbling known as *suminagashi* is an ancient Japanese technique, which translates simply as 'ink floating'. It involves a highly instinctive and satisfying process that closely connects the crafter, the ink and the water.

No one knows the exact origins of *suminagashi* but there are examples of this type of work as early as the twelfth century. It may not be in the history books, but I love the story of how an imperial calligrapher discovered it by chance. A droplet of his calligraphy ink fell onto some water from his brush. Watching as the ink dispersed on the surface, he took a piece of paper and placed it on top of the water, capturing the patterns created by the inky swirls. So much of the marbling process has to do with chance, observation and curiosity.

Another type of marbling, *ebru*, which is Turkish for 'cloud-like', originated in Turkey, Persia and India during the fifteenth century. This used thickened water, which was similar to the marbling solutions of today. There is a big difference between these two marbling techniques in both their process and outcome. In *suminagashi* marbling the ink moves freely on the water's surface and creates organic patterns by simply being encouraged to move by the air. The better-known *ebru* marbling techniques, which are very controlled, aim to create identical pieces.

Using this book

In this book, you will be expertly guided through every stage of paper marbling, from the initial preparation needed right through to your very own finished pieces, along with handy tips and answers to frequently asked questions about the process. Marbling is a very simple craft, suitable for all ages and perfect for exploring over a weekend – either as a mindful and relaxing creative exercise or enjoyed with others for a fun and bonding experience.

Inks are placed onto the surface of a tray of water, where they begin to expand and move. The colours move in a natural way, only encouraged to move by the air; nothing else disturbs the surface. When a dynamic pattern has been created, a print is made by placing the paper onto the water.

There is no right or wrong with this process, everyone uses a different and individual approach. This is one of the most fascinating parts of the craft for me. The outcomes are so different every time and really reflect the personality of each individual marbler.

There are many different uses and crafts that you can try with your finished piece of marbled paper. Included in the book are step-by-step projects showing how to make gorgeous items like greetings cards, tags, bunting, wallpaper and more. Or you may prefer to simply put your unique piece of art in a frame to display in your home.

Wallpaper making and paper marbling have been listed as endangered crafts by The Heritage Crafts Association. I am constantly striving to innovate and re-imagine these crafts, not only preserving them but making them relevant and accessible for the future.

MATERIALS

You don't need a lot of specialist materials and equipment to begin paper marbling: this basic kit shows you how simple it can be to get started. The items here can easily be found in art and craft shops, online and some even in the household aisle of your local supermarket. On the following pages you will find more detail about different types of paper and ink to use for varying effects and information on how to scale up the size of your work. See page 78 for suppliers of inks and papers.

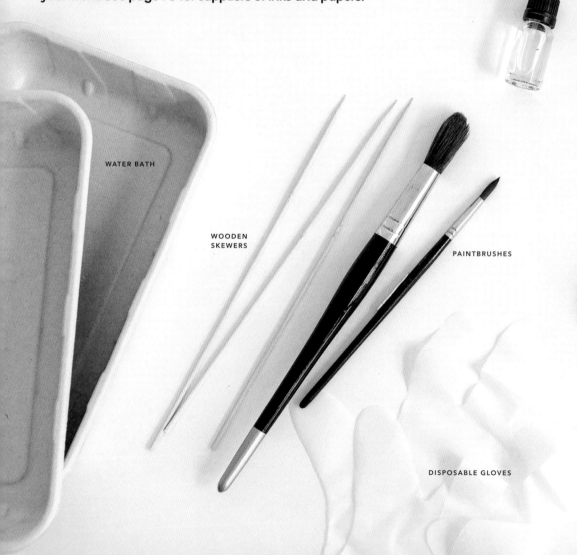

FLOW AID

WATER BATH

WOODEN
SKEWERS

PAINTBRUSHES

DISPOSABLE GLOVES

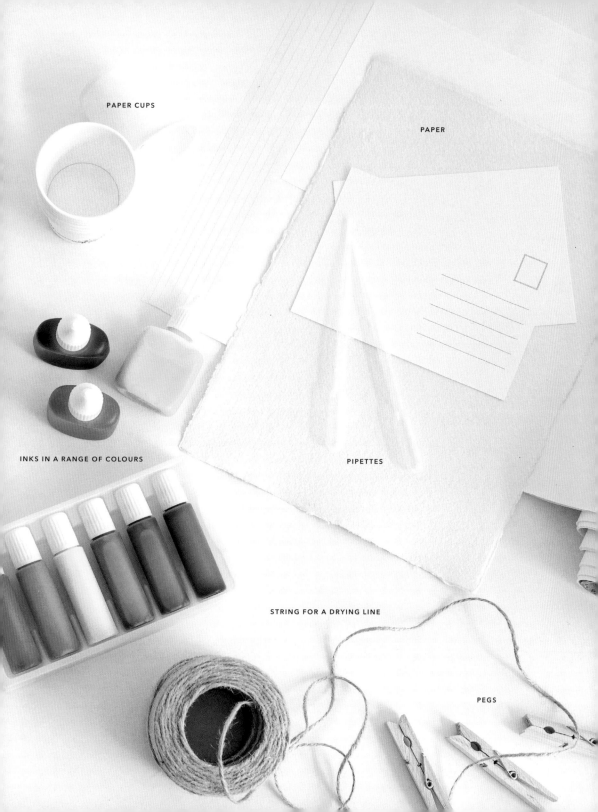

PAPER CUPS

PAPER

INKS IN A RANGE OF COLOURS

PIPETTES

STRING FOR A DRYING LINE

PEGS

Preparation

- Clean, clear work surface
- Newspaper or old towels
- Disposable gloves

Cleaning up

- Disposable gloves
- Washing-up liquid
- Sponges and cloths

Printing

- Flow aid
- Marbling inks
- Paper
- Food trays
- Paddling pool
- Paintbrushes
- Wooden skewers
- Pipettes
- Paper fan
- Kitchen paper
- Paper cups

Paper crafts (see also, project pages)

- Pencil and eraser
- Metal ruler (standard and long)
- Scissors
- Craft knife
- Hole punch
- Masking tape
- Double-sided tape
- Paper glue
- Lampshade kit
- Wallpaper glue
- Wallpaper smoothing tool
- Plumb line

Drying your work

- Washing line or string
- Pegs
- Drying rack (optional)
- Heavy objects for flattening

Avoiding waste

One of the reasons I was so drawn to the art of paper marbling is its potential for sustainability. The water baths can be used again and again and because the inks sit on the surface of the water, they can be removed to simply make way for the next print run. You don't need to fill your water bath with a lot of water – only an inch or two would be plenty. When you have finished printing, this should leave you with very little water to dispose of: after removing the inks, you can simply pour the water away down a sink.

Old food containers can be reused many times as water baths and you can keep them going as long as they are watertight. Any marbled pieces that haven't been successful or have offcuts can be kept for other purposes: for example, cut them up and make small items like gift tags (see page 46) or paper leaves (see page 57). Much of the paper I use is from recycled sources, see page 78 for suppliers.

Working with children

Paper marbling is a wonderful family activity and a great craft to learn with children. It is an instinctive process and children really connect with the freedom to have a go and experiment. There is no right or wrong with these techniques: just playing and practising, seeing what works and what doesn't and, ultimately, which results you like best! The best inks to use when marbling with children are non-toxic oil- or water-based inks such as the Scola and Aitoh marbling inks (see pages 12–13 for more information). A fun way to enjoy a group paper marbling session is to set up a paddling pool in the garden where everyone can work on their pieces together and mess is encouraged. Just make sure to have a separate pool for paddling once it has become a marbling pool!

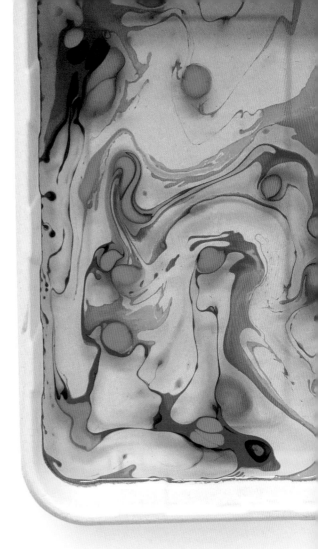

Getting messy

You will need to dress for mess: these inks are non-toxic, but can stain your clothes, surfaces and skin. Make sure you have newspapers or old towels available to cover surfaces and products for cleaning up afterwards. Only use containers for a water bath that you do not want to use for another purpose.

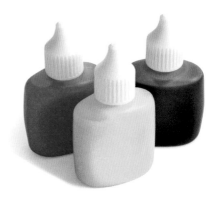

Types of marbling ink

There are different types of marbling ink available to buy online and in art shops. I have listed some popular types that are suitable for the *suminagashi* marbling technique, along with information about their characteristics and ease of use.

You can use the step-by-step guide on pages 20–23 for all the types of ink mentioned on these pages. Although the end result can look different, the process is very similar. We are simply floating inks on water!

Oil-based inks

Oil-based inks allow an expressive way of marbling as you can play with them while the ink is on the surface of the water, giving endless possibilities for experimenting with new patterns and effects. It is also possible to make multiple prints from each application of ink.

Scola marbling inks are linseed oil-based, non-toxic and wonderful to work with. They are eco-friendly and give great results. The easy-to-use, dropper-top plastic bottles come in sets of six different colours including black, blue, red, yellow, green and orange. You can also buy sets of neon and metallic inks, which are also used in these projects. Experiment with making your own oil-based marbling inks by mixing together any type of oil paint and oil paint solvent from art suppliers, such as Zest-it.

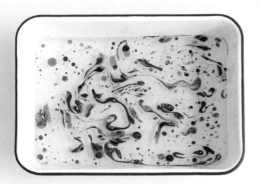

OIL-BASED MARBLING INK CAN BE EASILY MANIPULATED ONCE ON THE SURFACE OF THE WATER.

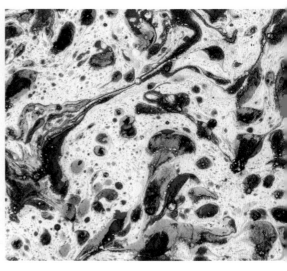

A FINISHED PRINT USING OIL-BASED INKS.

Solvent-based inks

These have a very different effect from the oil-based inks. When applied to the surface of the water, they disperse and then freeze into their pattern position. The pattern is decided by the inks so you won't be able to manipulate it. The inks turn into a filmy substance creating a crackled effect on the surface. Each application of ink allows just one print as the leftover ink breaks apart as soon as you lift the paper from the water.

Marabu Easy Marble are solvent-based inks that are touch dry after about 15 minutes. They are permanent when used on paper but will wipe off other surfaces. Decorated objects are therefore not washable. Available in many colours, these inks are sold individually. You could also try Kreul Magic Marble inks for a similar effect.

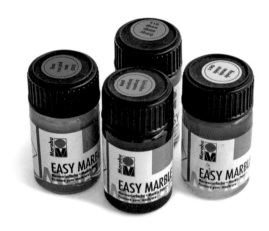

SOLVENT-BASED MARBLING INK HAS A CRACKLED APPEARANCE ON THE SURFACE OF THE WATER.

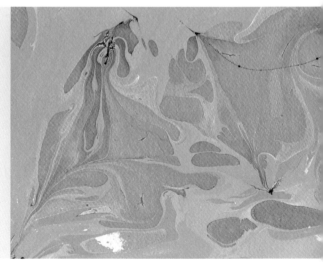

A FINISHED PRINT USING SOLVENT-BASED INKS.

Water-based inks

These inks have the most similar characteristics to the ones used for traditional *suminagashi* marbling. Being water based and mixed with pigments, they tend to drop to the bottom of the water bath when applied, leaving smoky, cloud-like patterns on the surface of the water. The patterns created are often very delicate and need very absorbent paper, such as rice paper, to be able to capture them. You will be able to get a couple of prints out of each application but the inks will disappear slowly afterwards. These inks allow for dream-like effects, capturing delicate moments on your paper.

Aitoh marbling inks are made of high-grade cosmetic pigment with PVA using a special process. They are non-toxic and sold in packs of multiple colours.

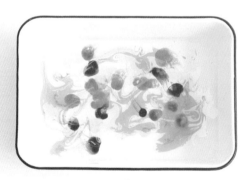

WATER-BASED MARBLING INK HAS A CLOUDY APPEARANCE ON THE SURFACE OF THE WATER.

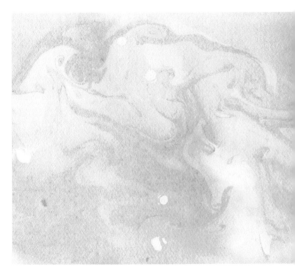

A FINISHED PRINT USING WATER-BASED INKS.

Dispersants

Traditional *suminagashi* patterns are created by absorbing inks onto paintbrushes, then lowering them to touch the water's surface. In order to create the patterns and differentiation between the coloured ink, marblers also use a brush dipped in dispersant. This dispersant acts like a transparent layer of ink and helps create the negative space in the patterns (see page 20).

Dispersants you can try are:
Liquitex Flow Aid
Washing-up liquid
Linseed oil

Mixing inks together

Some marbling inks are only available in basic colours, such as red, blue, yellow, green and black. If you want to experiment with more subtle shades, you can mix the inks together to use in your marbling.

All you need for this is a paper cup and a pipette. Add the colours from the inks you want to try mixing together into a paper cup and stir them thoroughly. Drop a little onto a piece of paper to see if you like it, or transfer them straight into your water bath and see what results you get. Make a note of your favourite combinations and how many drops of each ink you used so you can revisit them for other prints.

You will be able to create purple out of blue and red, turquoise out of blue and green and orange out of red and yellow. Brown tones are made by mixing the primary colours, blue, red and yellow. Vary the amounts of blue and red to create cooler and warmer tones. Most packs of marbling inks include black, which is useful for mixing darker, less saturated shades of other inks.

Types of paper for marbling

The most important thing to remember about marbling with paper is that it should be uncoated. This way, the ink will be absorbed easily by the texture of the paper and give you the best results. The thicker and heavier the paper is, the more it will absorb the ink. Thinner paper lends itself to delicate prints, capturing light ink coverage on the surface of the water. If you have added lots of inks that are creating a very full and vibrant image, a thicker paper is more suitable. Some of my favourite papers to work with are listed below.

1. Watercolour paper
Due to the nature of watercolour paints, the paper used tends to be uncoated and beautifully textured, making it ideal for paper marbling. You can purchase watercolour paper pads in various sizes, from A6 to A2, and it is widely available from art suppliers. Watercolour paper will be most suitable for creating postcards, greetings cards, tags, artworks, garlands and bunting.

2. Heavy cartridge paper
A smooth, versatile paper used for many printmaking techniques. This heavyweight paper can be purchased in convenient sizes from A6 to A2, as single sheets or pads. Cartridge paper is suitable for all types of stationery, garlands and bunting, paper leaves and flowers.

3. Handmade cotton paper
This paper is very special and works wonderfully with paper marbling techniques. Made from long-fibred cotton rag, it is ultra-absorbent and creates very vivid and beautiful prints. Khadi papers can be purchased directly or from art suppliers and the papers range in size and weight so you can choose what works best for your own projects. This paper is suitable for artworks, garlands and bunting.

4. Lining paper
Good-quality lining paper can be bought in rolls from any hardware or DIY store. They can be bought in different lengths and cut to the size you need. Available in different grades, the thicker types are suitable for artworks, wallpaper and lampshades and the thinner types are suitable for wrapping papers. Avoid the ones with added treatments or coatings.

5. Japanese rice paper
These papers are very delicate and mostly used with the traditional *suminagashi* marbling process as the rice paper is very absorbent. These papers can be purchased through specialist art shops and are usually sold in rolls. This paper is very suitable for using with water-based inks and creating wrapping paper, artworks, paper leaves and flowers.

Experimenting with coloured paper

You can also have a go at using coloured papers for your marbling projects. Lighter shades will allow the marbled patterns to be more visible once dried. Brown packaging paper is also an affordable alternative and comes in large rolls. (See the wrapping paper project on page 48.)

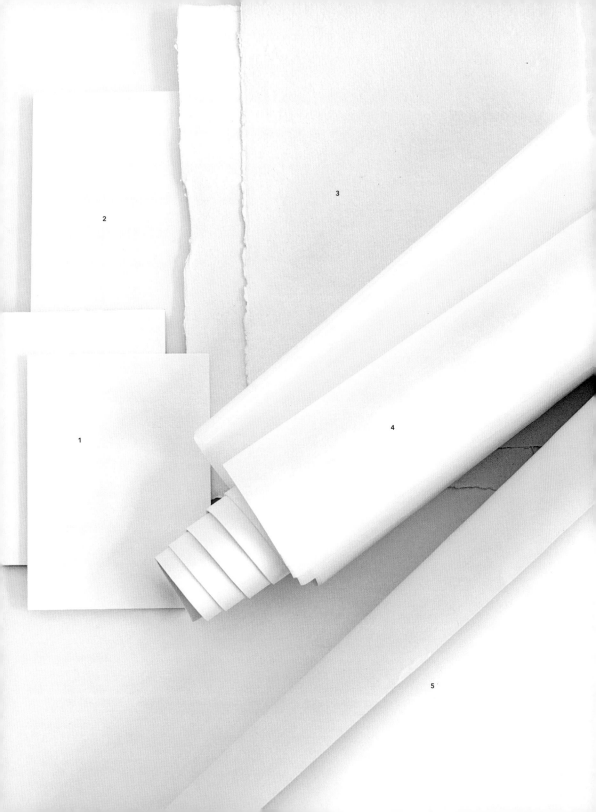

Choosing a water bath

The projects in this book use sheets of marbled paper in varying sizes, which means you will need water baths that work for every scale. For example, the stationery only needs small pieces of paper: therefore a small water bath can be used for the printing. The lampshade and wallpaper projects use large sheets of paper so you will need to scale up the printing process with a larger bath.

It's best to use trays with a light-coloured base, so you can easily see the colours on the surface of the water. If it is too dark then you won't be able to see what's happening to the inks.

A MEDIUM-SIZED WATER BATH BEING USED.

YOU CAN BUY A RANGE OF DIFFERENT FOOD TRAYS, WHICH MAKE EXCELLENT SMALL WATER BATHS FOR MARBLING.

Small water baths
Trays from food packaging are ideal for using with smaller-scale prints. You can re-purpose used ready-meal trays by washing them. Compostable food trays are available to buy in bulk and will work perfectly as water baths.

Medium-sized water baths
Aluminium baking trays, shallow household tubs and basins will all work well, but don't use anything that you don't want to be stained with ink.

Large water baths
A children's paddling pool makes an ideal makeshift water bath for producing large prints. It can be deflated and packed away easily, making it a practical option if you don't have lots of room. I have an extra-large custom-built water bath that is invaluable for producing sheets of wallpaper in large quantities.

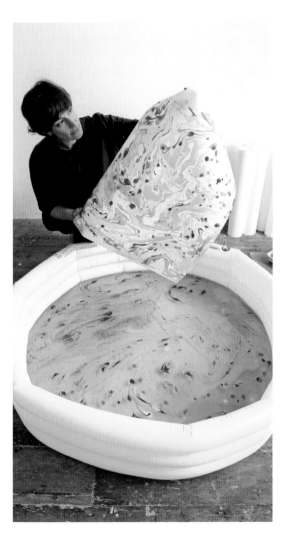

Setting up the water bath

1. Place some newspaper or old towels around and underneath the water bath to protect the surrounding surfaces from any spills.

2. Fill the water bath to around 2in (5cm) deep with water. Tepid water helps the inks to disperse – I have found that when the water is too cold the inks don't spread well and when the water is too warm they can spread too fast.

3. You won't need to refill the bath with water after each print run as the inks tend to float on top of the water and can be removed by simply skimming some kitchen paper over the surface (see page 26). The water should last for many print runs.

4. If the water gets murky (which can happen with the water-based inks) then you can change the water more often to be able to see the emerging patterns.

Staining

Remember that the inks may stain the edges of the water bath so do not use anything valuable or that you want to keep for another purpose. For this reason, don't be tempted to use the bath in your bathroom!

MAKING A PRINT

Follow these basic steps to make a marbled print. Start by playing with just one colour and some flow aid to help you get to know how the ink behaves on the water. Then you can progress to using multiple colours and more complex patterns.

You can use as many colours as you like; there are no rules for how many, it depends on your taste and how you feel on the day. See pages 32–37 for ideas and inspiration for choosing your colours. You will get into a flow of movement quickly and want to keep inks (and your drying station) nearby so you can enjoy the process. To continue experimenting, try the different ways to apply inks and move them on the water (see pages 24–29).

What you will need

- Small or medium-sized water bath
- Flow aid
- Marbling inks in multiple colours
- Pipette
- Paintbrush
- Paper to print on
- Kitchen paper
- Paper cups (if you are mixing inks)
- Newspapers, washing line or drying rack

Playing with one colour

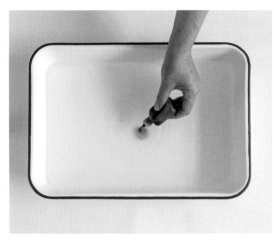

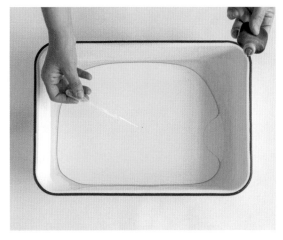

1. Start with one colour Fill a pipette with flow aid. Hold it in one hand and a bottle of ink in the other. Slowly squeeze the ink bottle to release a couple of drops.

2. Add flow aid Now add a drop of the flow aid on top of the ink and watch as it disperses to the edges of the water bath. The flow aid acts as an invisible ink and you can have fun experimenting with it.

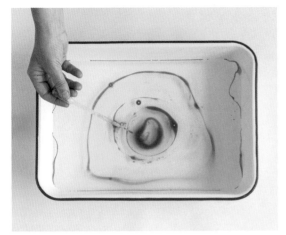

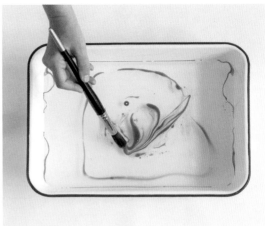

3. Keep going Repeat steps 1 and 2, adding alternate drops of ink and flow aid until you create a ripple effect on the surface of the water.

4. Move it around Move the ink in different directions by gently blowing or using a paintbrush. You will see the ink begin to move and form fluid patterns. When you see one you like, follow the instructions from step 5 onwards on page 22 to make a print.

Printing with multiple colours

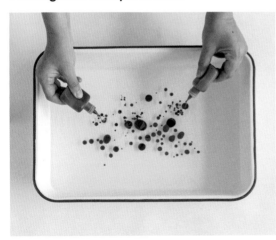

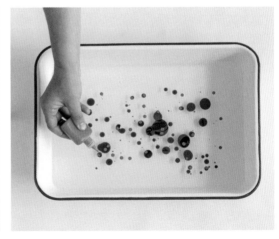

1. Add the darkest ink first Have your chosen inks to hand near your water bath. Start with the darkest colour as those pigments will take a little more time to spread and develop. Squeeze drops onto the surface of the water.

2. Add more colours Apply more drops depending on the balance of colours you would like to create. You can vary the quantity and position of the inks dropped onto the water however you wish.

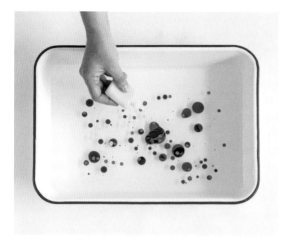

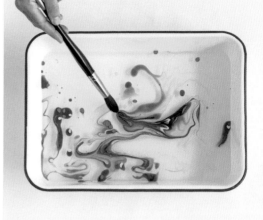

3. Placing colour If you would like a specific colour to be a dominant or background colour then start with this one to create a base. Then layer the other colours in turn. If you would only like a hint of a colour in your print, then only use a few drops.

4. Move the inks around Once you have added all of the colours you want to use, gently blow on the inks to encourage a marbled effect. (See pages 26–27 for different ways to do this.)

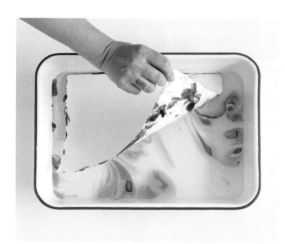

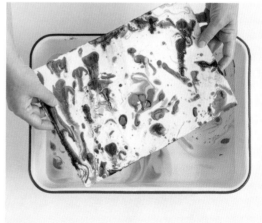

5. Make a print When you see a pattern you like, take a piece of paper and gently place it on the surface of the water. Tap it slightly to release any air bubbles then pick up one corner and slowly peel it away.

6. Dry your print You will see how the patterns have transferred from the water's surface to your paper. Now place your paper on the side or hang it up to dry (see page 30).

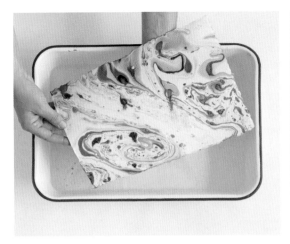

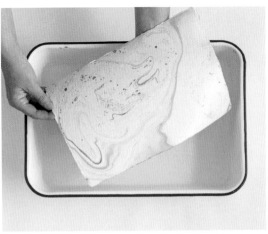

7. Repeat the print ... You'll notice that the inks left in the water will have now moved into brand-new shapes and patterns. Take another piece of paper and repeat Steps 5 and 6 to make another print.

8. ... and again if you can There are often very delicate colours and patterns still sitting on the surface of the water that you might hardly be able to see. It's always worth having another go at printing, to capture paler, pastel shades with dreamy results.

Reuse the same water
You can reuse the water again and again using any type of ink. Just keep cleaning the surface with kitchen paper. If you are using oil-based inks, the oils actually help with the distribution of the inks the more often you use it. The water-based inks may make the water murky over several print runs so change it more often if required.

9. Clean the water When you have finished the print run, take some kitchen paper and pull it along the surface of the water to capture the last of the inks. You can keep the same water in the bath to start a fresh print run.

APPLYING INKS

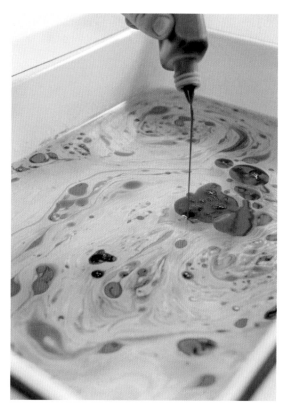

Applying the inks and then taking the time to watch them create their own patterns is an instinctive process. You can just observe them taking shape and simply place the paper when you want to capture an interesting pattern. But there are other ways to encourage your inks to move around on the surface of the water. The simplest way to apply the inks to the surface of the water is to take a bottle and squeeze the dropper of ink. If you are mixing your own colours you will have a pipette, but there are other ways of applying inks for different effects.

Tape the bottles together

Try taking a selection of ink bottles, tape them together and then squeeze or shake them all at the same time. This is a very good way of creating a vibrant and dynamic pattern. The inks are applied more vigorously this way and react accordingly.

Tape multiple ink bottles together ...

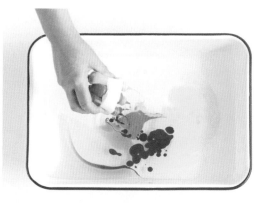

... to create an immediate and dynamic pattern.

Apply ink at the edge of the water bath

To create softer shapes, I sometimes apply the inks to the edges of the water bath.
The inks will slowly run down the side and start to spread out very slowly and evenly.

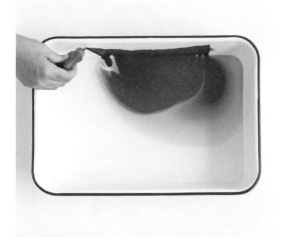

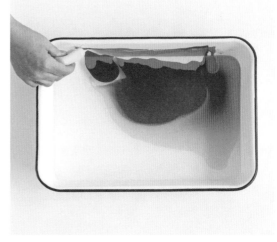

1. Start with one colour You can use different inks and apply them together, one after another. Apply the darkest colour to one side of the bath.

2. Layer the colours Apply more colours all on top of each other along the side of the bath. These will create ripples that will slowly fan out on top of the water.

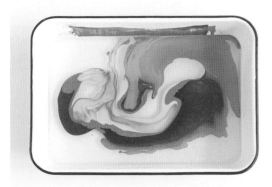

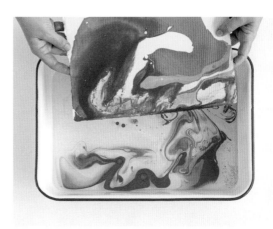

3. Observe the pattern You can either leave it to develop all on its own, or give it a blow.

4. Print This creates a very soft pattern, which you can make multiple prints from.

MOVING INKS

Oil-based inks tend to create the best patterns when interfered with as little as possible: a gentle nudge is often all they need. They can separate and turn blotchy on the surface if they are disturbed too much. Water-based inks sit very delicately on top of the water so they also work better with gentle blowing or a brush to move them. The solvent-based inks can freeze on top of the water as you drop them in. But you can still easily move them with an object, such as a brush, at the beginning to create quite vigorous and striking patterns.

With your breath, or a fan

This is one of the traditional *suminagashi* marbling techniques, allowing you to be in control of how gently or vigorously you would like to move your inks. It also gives you control over which direction you want the inks to move. Inks often linger in corners and you can easily encourage them back to the centre by gently blowing them. I use a paper fan, which allows you to move the

inks over large areas of water without becoming out of breath! Go in close to the water or pull away for a gentler effect. You can also use a hair dryer but make sure you use the lowest setting and keep it well away from the water.

Removing ink

If you feel there is too much ink on the surface of the water and you would like to give the patterns more space, you can use a piece of kitchen paper to skim the surface and remove some of the ink. This leaves more room for the remaining inks to spread.

Do your marbling outside

By setting up your water bath outside you can take advantage of any breeze or gusts of wind that will do the work of moving the inks for you.

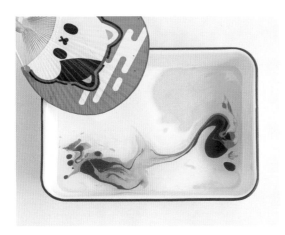

A paper fan allows you to move the inks around.

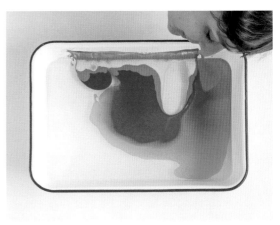

Blowing gently can help you target a particular area.

With a paintbrush or wooden skewer

You can also use a round-headed paintbrush or wooden skewer to paint on the surface of the water with the inks. This creates more localised and specific shapes as you can use the tool to encourage intentional pattern making. You can use any fine object: toothpicks, a hair or, traditionally, even a cat's whisker! These objects will encourage incredibly fine movements and pattern making.

Pattern spotting

The most interesting patterns aren't always where you think they will be. It is often the more subtle areas that create the best marbled effect, rather than the more obvious blobs of colour.

Fine objects allow you to draw with the ink.

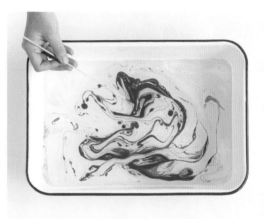

You can pull the inks into shapes and patterns.

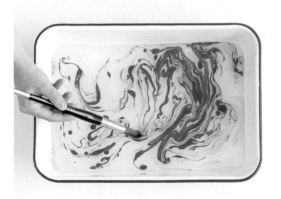

Paintbrushes give a softer effect ...

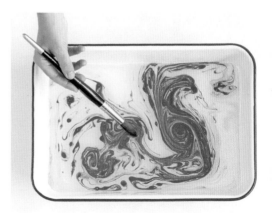

... encouraging swirls and drifts of ink.

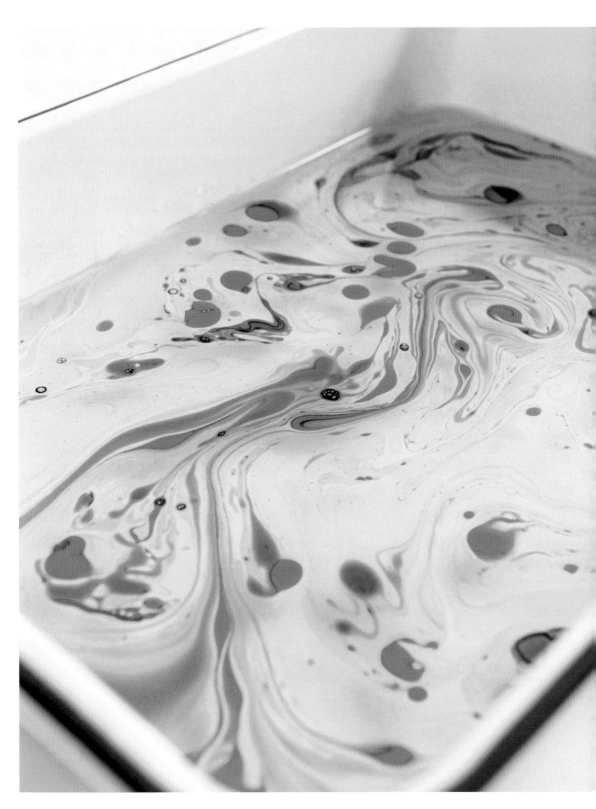

Moving paper on the water

Interesting effects can also be created by moving the paper on the surface of the water. This is a very experimental process and you can trial different movements while placing the paper for printing. One of my favourite effects is a wave pattern created by bending the paper so only a section at a time will touch the water. Wave patterns are particularly appropriate for the medium of marbling as they accentuate the fact that the patterns are created using water.

Making a wave pattern

1. Apply the inks A light and even spread of ink works best for the wave pattern.

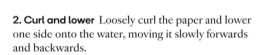

2. Curl and lower Loosely curl the paper and lower one side onto the water, moving it slowly forwards and backwards.

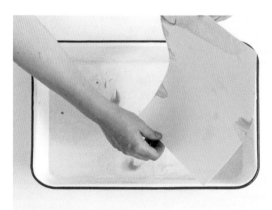

3. Print both sides Lift it off and repeat the forwards and backwards motion for the other side of the paper.

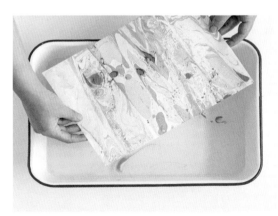

4. See the results You will achieve a striking wave effect across the entire piece of paper.

DRYING YOUR WORK

You can dry your prints on a flat surface or a drying rack if you happen to have one. You will find you run out of space quite quickly so I tend to stretch a string across the room and peg the prints to it. A clothes airer would also work well. The print will be wet and dripping so make sure to lay some old newspapers or towels underneath.

The wet inks of some prints may run if you hang them up straight away so dry flat until they are stable enough to hang up. Paper prints usually take between half an hour to an hour to dry (depending on the weight of the paper). Once your pieces have dried enough that the papers are damp instead of wet, you can weigh them down with a flat, sturdy object to keep them flat, if a very flat finish is desired for your end use.

Double dipping

Once your marbled creations have dried, it is possible to marble them for a second time. When the paper is wet it will not absorb any more ink, but once it is dry again it will give you a whole new depth and technique to play with. I often use the double-dip option when a print has turned out too pale or I would like to add another colour. You can repeat this process until you are satisfied with the result. This is why marbling is so exciting: the possibilities and discoveries of new results are endlessly rewarding!

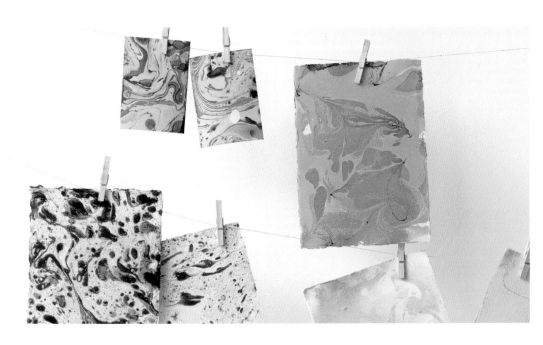

TROUBLESHOOTING

You may experience some of these common problems while you are getting to know the process of paper marbling. This useful checklist will help you identify and overcome them quickly.

Oil-based inks

Problem: The inks aren't spreading evenly.
Solution: This can be due to too much ink on the surface of the water. Remove excess ink by placing kitchen paper on a small area of the water bath to absorb some ink, helping to create more room for them to spread.

Problem: The inks stay in blobs.
Solution: This can happen with the darker inks because of their pigmentations. Each one has its own characteristics and may need more encouragement to spread. Try dabbing some kitchen paper on the blobby parts to help them move. If the problem persists, remove the inks from the surface with kitchen paper and start again.

Solvent-based inks

Problem: The inks freeze and turn into a gloopy consistency before I have made a print.
Solution: This is the character of these inks so speed is of the essence to achieve your desired patterns. Move the inks as soon as they are on the water's surface. Remove the inks and start again if this happens.

Water-based inks

Problem: The inks aren't taking to the paper.
Solution: The water-based inks need the most absorbent of papers, so make sure the paper you are using is uncoated.

General

Problem: There are white areas within the prints.
Solution: When you place the paper onto the surface of the water it can create air bubbles, which prevent the inks from touching the paper. You can stop this happening by placing the paper along one side first then lowering the rest of the paper in slowly. Always give the paper a little tap to help air bubbles escape.

Problem: The final marbled papers are warped.
Solution: Placing your printed papers underneath a stack of heavy books for a few hours when they are slightly damp will ensure they are flat enough to use for the artwork or paper crafts.

COMBINING COLOURS

Some days I really love to throw as many colours as possible together and see what the outcome is. But at other times I just want to take it a bit more slowly and only use one or two colours to create quieter pieces. Use these pages to help find your own personal colour preferences.

Finding your inspiration

J.M.W. Turner said that 'the skies over Thanet in Kent are the loveliest in all Europe', which is also where I draw my inspiration. The changing colours of the sky and sea have given me endless motivation in my work. Many of my own colour palettes are drawn from and named after pieces by other masters of colour like Helen Frankenthaler, Anni Albers, Georgia O'Keeffe, Gustav Klimt, Paul Klee and Henri Matisse.

I also like to observe objects I have collected over the years. The history and colour combinations of many of these things are starting points for my marbled art pieces, like *matryoshka* and *kokeshi* dolls, handmade ceramics and textiles. Found objects from the sea, like fossils and shells (especially scallop shells), wildflowers and plants found in the garden and surrounding areas are also important to my colour-finding process. You don't always need to look very far to find colours that draw you in: a small, everyday object can capture your attention and might become part of your favourite colour palette.

Escape your comfort zone and experiment with colours. I used to begin most of my projects with a blue base but that has changed over time through commissions and projects for myself. I tend to work with brighter colours during spring and summer and turn to moodier colours in the autumn and winter. See some of my favourite colourways on pages 35–37.

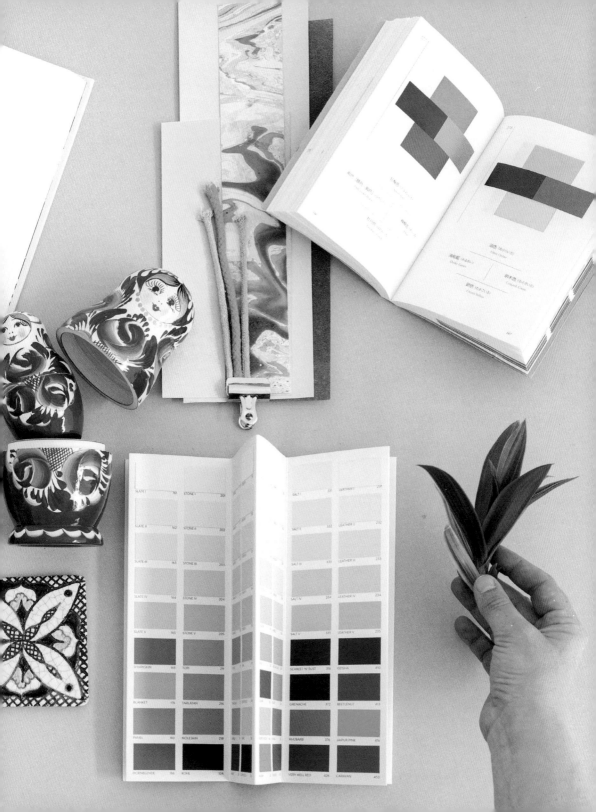

Design considerations

Your colourway might depend on the type of finished project you are intending to create and a good place to start your planning is to consider any practical issues.

If you want to use your marbled prints for interiors projects, like hanging art (page 41), lampshades (page 73) or wallpaper (page 65), make sure you include colours that will suit the room and furniture where the piece(s) will be placed. You may wish to tie in an accent colour with the surrounding scheme, create a high-impact tonal clash or a background colour that blends in quietly.

Think about the direction your room faces and how much natural light it gets. South-facing rooms enjoy strong natural daylight so most colours work well in these spaces. Here, you can really be brave using blues, greens and violets. North-facing rooms have a cooler natural light and, generally, less of it, so these spaces benefit from warmer shades such as pinks, golds and yellows. East-facing rooms will have natural light in the morning and west-facing rooms in the evening. Consider if you want to balance the sunlight with blues and greens or make your room feel cosy when the natural light is at its minimum by adding warmer tones.

For stationery (see page 43) or display projects (see page 41), you can be as creative and experimental with colours as you like. These can provide a perfect opportunity to trial new colourways.

Mixing inks

Don't be afraid to create your own shades of marbling ink: you don't have to stick to the basic colours that are sold. See page 15 for instructions on how to do this.

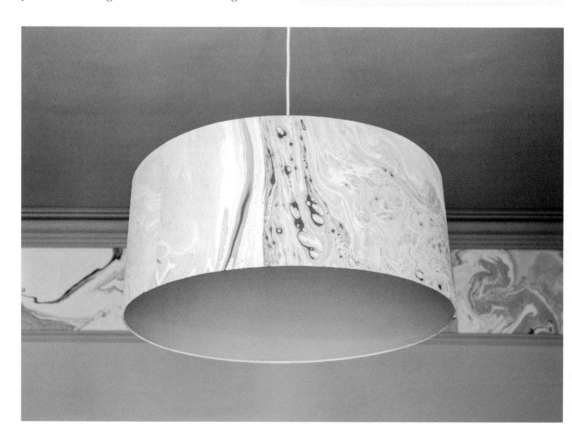

Vibrant colourways

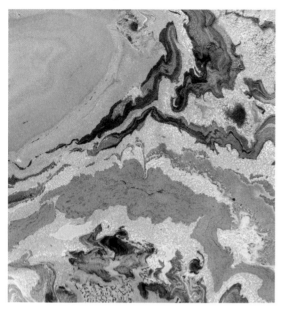

AGATE: TEAL, GREEN, BROWN, YELLOW AND PURPLE.

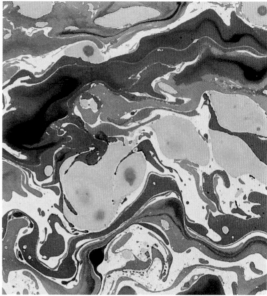

AUTUMN: GREEN, PURPLE, ORANGE AND NEON ORANGE.

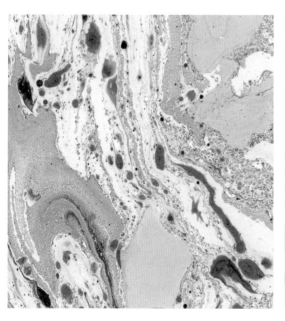

CORAL: PINK, YELLOW, GREEN AND RED.

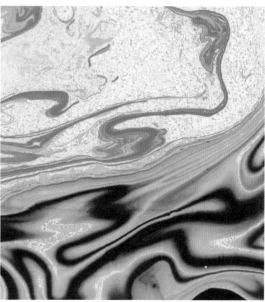

FIRE: ORANGE, BROWN AND TEAL.

Quiet colourways

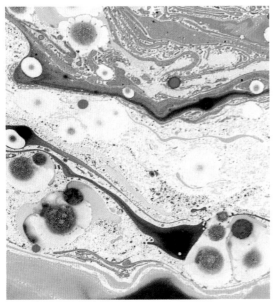

KLIMT IN BLUE: BLUE, TURQUOISE, BROWN AND ORANGE.

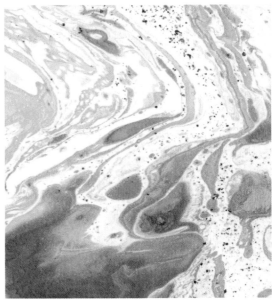

KLIMT IN GREEN: GREEN, TURQUOISE, BROWN AND ORANGE

TIDES: PINK, TURQUOISE, BROWN, ORANGE AND RED.

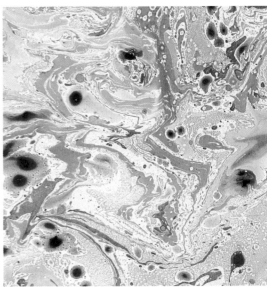

WINTER: BLUE, TURQUOISE AND PINK.

Popular colourways

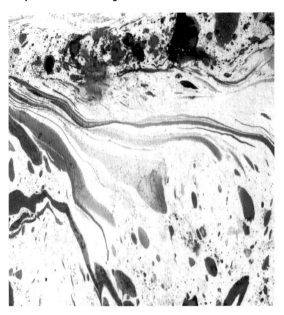

BAUHAUS: RED, BLUE AND YELLOW.

OCEAN: DARK BLUE AND NEON ORANGE.

SALT MARSHES: GREEN, BLACK, BROWN AND NEON PINK.

SPRING: BLUE, GREEN, PURPLE, YELLOW, ORANGE,
NEON ORANGE AND NEON PINK.

PROJECTS

Your journey with paper marbling does not end when the ink patterns have dried and the water bath has been cleared away. There are so many creative uses for the prints you create and this section explores just a few of the possibilities.

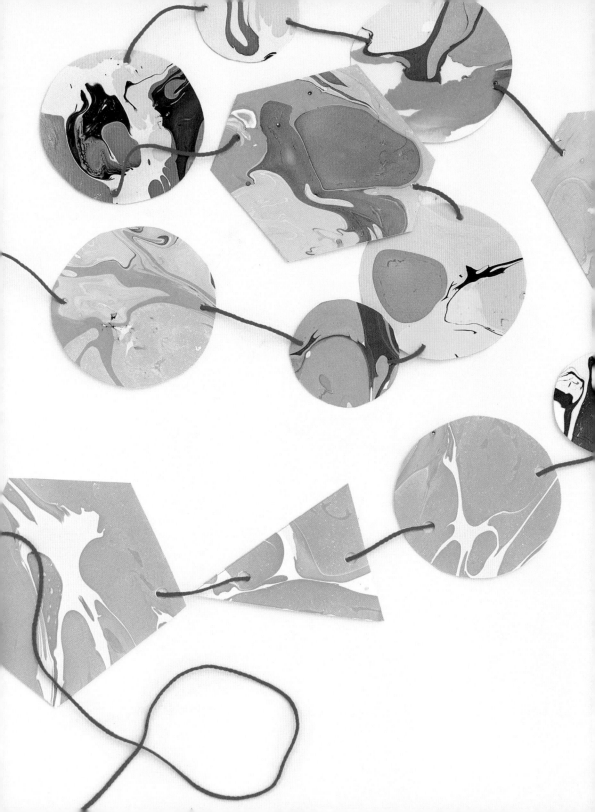

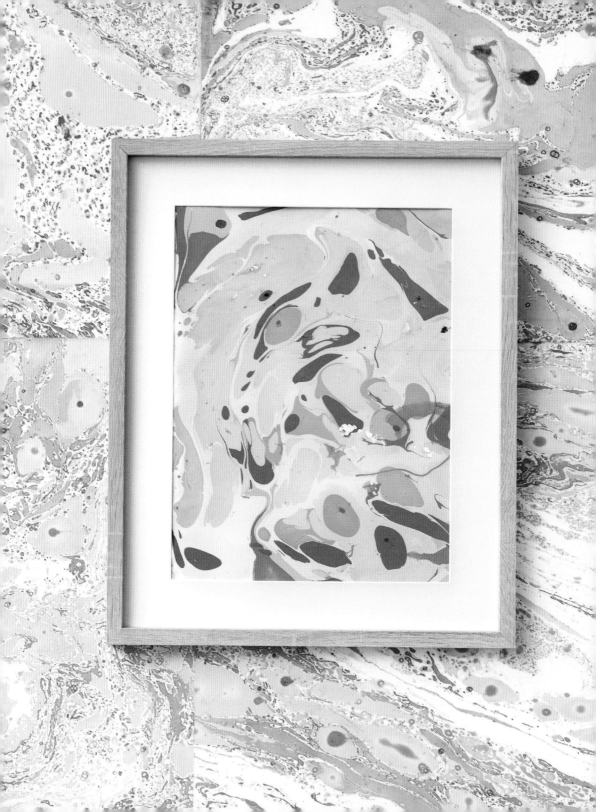

ART DISPLAY

Capturing your unique patterns onto large sheets of paper is a magical experience and showing them off as artwork on the wall gives your work a new perspective and a whole new audience. This is a wonderful beginner project with much impact and rewarding results.

Using a larger water bath, such as a paddling pool, (see page 19) will allow your marbling patterns to really come to life. I like to use A2 heavyweight cartridge paper for most of my art prints, which is a great size for displaying a set of two or three, or even more if you have a generous wall space available. Place the prints underneath a heavy object when damp so that they dry perfectly flat.

Smaller framed art prints can also make a wonderful display: try grouping them together to make an eye-catching arrangement. You can change your art displays as you create new prints that you love, tweaking and updating your collection into an evolving gallery. Art prints also make fantastic presents.

I would recommend using oil-based or solvent-based inks for vibrant colours and patterns. The artwork opposite is a print made with solvent-based Marabu inks and the wallpaper behind used oil-based inks. Playing around with a wallpapered backdrop for your display is a great way to layer pattern over pattern with either harmonious or clashing results, whichever you prefer! (See page 65–89 for how instructions on how to make and hang marbled wallpaper.)

I tend to use natural wooden picture frames as the grain of the wood works so well with the marbled patterns. I would also recommend white frames for a more minimal setting or even coloured frames that highlight a particular tone within your piece can be fun. Avoid black frames as these can draw attention away from the delicate patterns within your print.

What you will need

- Marbling equipment, see pages 8–9

- Your favourite marbled patterns printed on heavy cartridge paper

- Picture frames

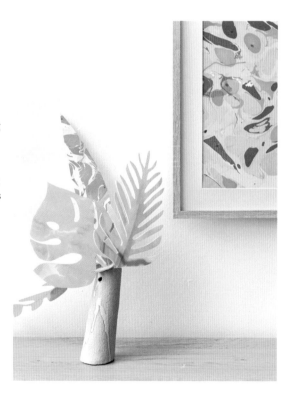

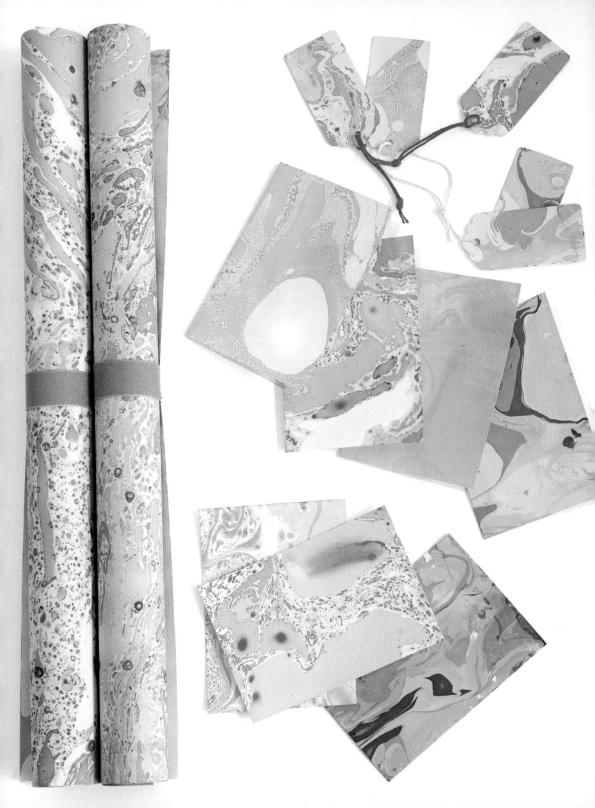

STATIONERY SET

When I started paper marbling some of the very first projects I tackled were printing postcards and tags: a great way to get to know the process. It was so much fun to look for interesting patterns forming in the water bath and create small pieces of colourful stationery, which I was able to share with friends and family.

For the smaller stationery items like tags and cards, you can either print them in a bespoke print run using a small water bath or use up leftover pieces from other marbled papers. The following pages show the former, but if you have a stash of offcuts, they can be used to create tags, postcards or botanical leaf shapes that will minimise waste and make the most of every scrap.

When printing with a small water bath, you don't need to add as much ink. The pattern needs space to form and small baths have less surface area to accommodate the ink. Printing several sheets each time also helps as every time you lift the paper it will have helped to create more patterns. Printing wrapping paper calls for a larger-scale water bath, using a paddling pool (see page 19). So get your drying station ready, and you will end up with a prolific collection of stationery.

What you will need

For all stationery

- Marbling equipment, see pages 8–9

- Cutting mat

- Pencil and eraser

- Metal ruler

- Craft knife

Postcards

- A6 pad of blank watercolour postcards or larger sheets of thick watercolour paper

Greetings cards

- A5 sheets of cartridge paper (or larger sheets to cut up)

Gift tags

- Paper for printing (any type will work)

- Tracing paper or access to a photocopier

- Stiff card for the templates

- Scissors

Wrapping paper

- Large roll of thin paper or lining paper

- Paddling pool

Postcards

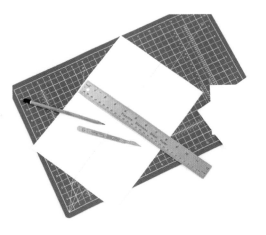

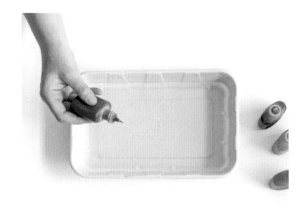

1. Cut the paper You can either use a ready-cut pad of watercolour postcards or slice up your own to the dimensions you would like. Mark out the size lightly in pencil on a large sheet of watercolour paper and then cut out using a metal ruler and a craft knife.

2. Prepare the water bath Set up a small water bath using a food tray a little larger than your postcard size. Select the inks you would like to work with.

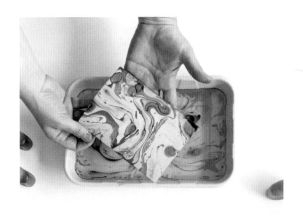

3. Printing the postcard Follow the instructions for printing on pages 20–23. Capture the patterns you like as you see them form.

4. Dry the postcards Hang them up to dry, weighing them down with a heavy object once they are damp, not when dripping wet.

Greetings cards

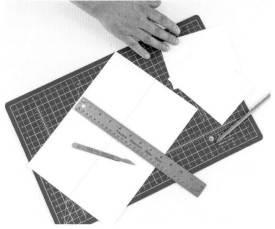

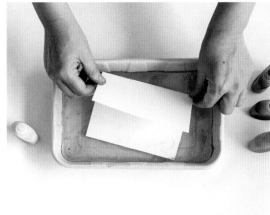

1. Cut and fold Fold the A5-sized cartridge paper in half. Alternatively, mark out the size you would like your card to be lightly in pencil on a large sheet of cartridge paper and then cut out using a metal ruler and a craft knife. Fold it in half.

2. Printing the cards Follow the instructions for printing on pages 20–23. Hold the greetings card on one side and place the other side onto the water to print. You can orientate your pattern to be portrait or landscape. Dry flat under a heavy object once damp.

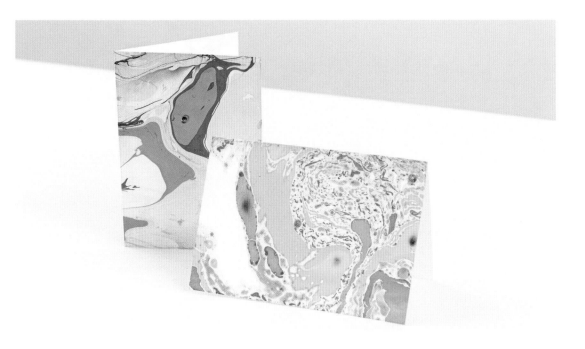

Gift tags

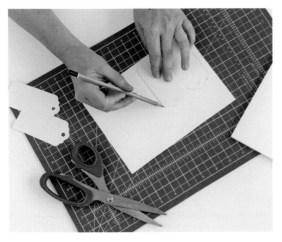

1. Make a template Choose a shape from the templates opposite and either trace it onto some card or photocopy it, then cut it out. Draw around the template onto a piece of plain paper as many times as you wish and cut out the finished tag shapes.

2. Set up for printing Fill a small water bath and choose the inks you want to use. Apply them to the surface of the water.

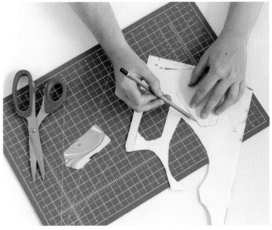

3. Print the tags Follow the instructions for printing on pages 20–23. When you see a pattern that you like, print the tags and allow them to dry before using.

4. Alternative method You can also make tags using scraps from other marbling projects. Draw around the template on the back of the marbled paper and cut it out.

Wrapping paper

To make your own unique wrapping paper, print onto large sheets of paper following the same steps for wallpaper on pages 65–66. Here, black ink was printed onto brown parcel paper to make an unusual monochrome design. I also use leftover wallpapers as wrapping paper to reduce waste and make a big impact when giving presents. Follow these steps to wrap up a book without using any tape.

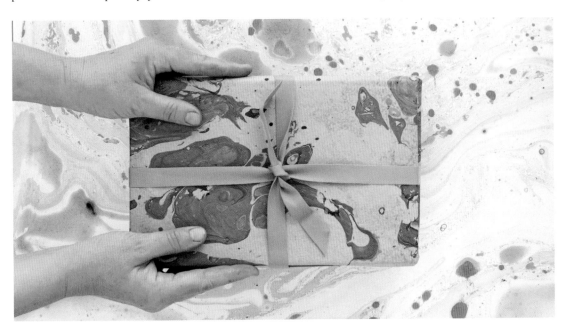

Wrapping a present with no tape

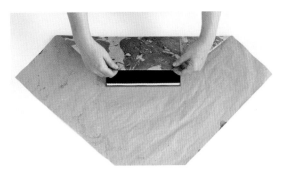

1. Get in position Trim your sheet of marbled paper into a square and place the book in the middle. The square should be big enough that when the sides are folded in they cover the book.

2. Start folding Fold one corner of the square over the book. Fold and tuck the corner you brought over into the front cover of the book to anchor it in place.

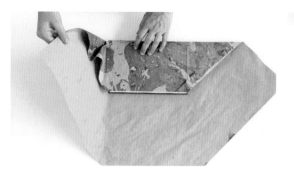

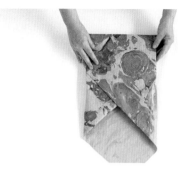

3. Fold and tuck Fold one side over, making a tuck at the side for the excess paper.

4. Repeat Do this again on the other side of the book, keeping the folds crisp and tight.

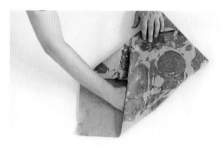

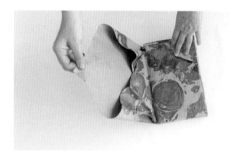

5. Score a line With your fingers, score a line along each side of the remaining flap of paper.

6. Wrap around Ease the remaining flap over the book, making the folded edge tight and crisp.

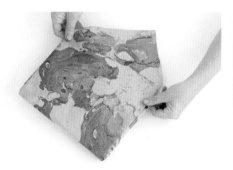

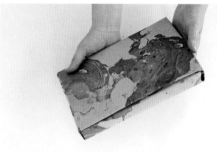

7. Make a crease Fold a crease along the edge of the book next to the overhanging flap.

8. Secure without tape Feed and tuck the flap into the gap to secure the wrapping.

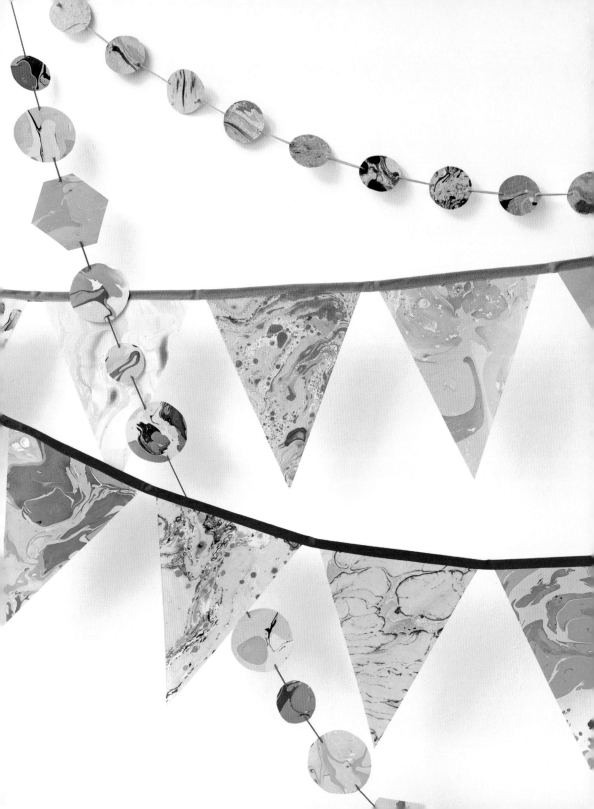

PAPER DECORATIONS

These decorations are great for creating small accents of colour in your home and make a cheerful display for seasonal or special occasions. They also make perfect presents – who doesn't love a bit of bunting?

Traditional bunting is given a marbled twist, with a modern and fresh appeal, and the strings of geometric garlands can be draped or dangled wherever you need a pop of colour. These are also wonderful projects for using up any leftover marbled papers and scraps to minimise waste.

I have used all types of marbling ink for the paper decorations. I like the different textures it gives to the composition of the bunting and garlands. Solvent-based Marabu inks create the most striking colour palettes, whereas the oil- and water-based inks will add more subtle results. Where your decorations will be displayed may determine the choice of the inks you choose.

What you will need

Traditional bunting

- Cutting mat
- Tracing paper or access to a photocopier
- Cardboard for making the template
- Pencil and eraser
- Sheets of marbled paper
- Scissors
- Paper glue (if making double-sided bunting)
- 1in (2.5cm)-wide ribbon, cut to length of bunting
- Double-sided sticky tape, slightly narrower than the ribbon

Geometric garland

- Cutting mat
- Tracing paper or access to a photocopier
- Cardboard for making the template
- Pencil and eraser
- Sheets of marbled paper
- Scissors
- Paper glue (if making double-sided shapes)
- Hole punch
- Length of cord or string, cut to desired length of garland

Traditional bunting

1. Copy the template Trace the template opposite or photocopy it, transfer it to the card and cut it out. Draw around it onto the marbled paper. Make sure you have enough flags to work with, roughly counting six per metre. Double the amount if you want double-sided bunting.

2. Make the flags Cut out all the marbled flags with scissors. If you want to have double-sided bunting, glue together pairs of flags with right sides facing out. This is helpful if you are displaying the bunting across a room.

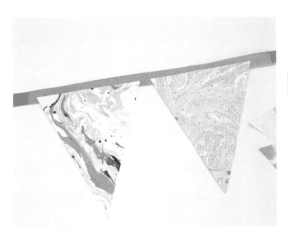

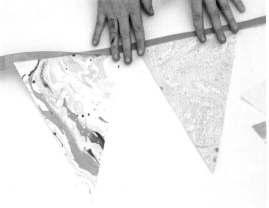

3. Position the flags Lay out your length of ribbon and stick double-sided sticky tape along one section. Remove the backing and stick down flags overlapping half the width of the ribbon. Leave a small gap between each flag and work in sections along the ribbon.

4. Secure the flags Fold the ribbon over to enclose the flags, making sure that the sticky tape has adhered to both sides, and the ribbon. Repeat for the whole length of bunting.

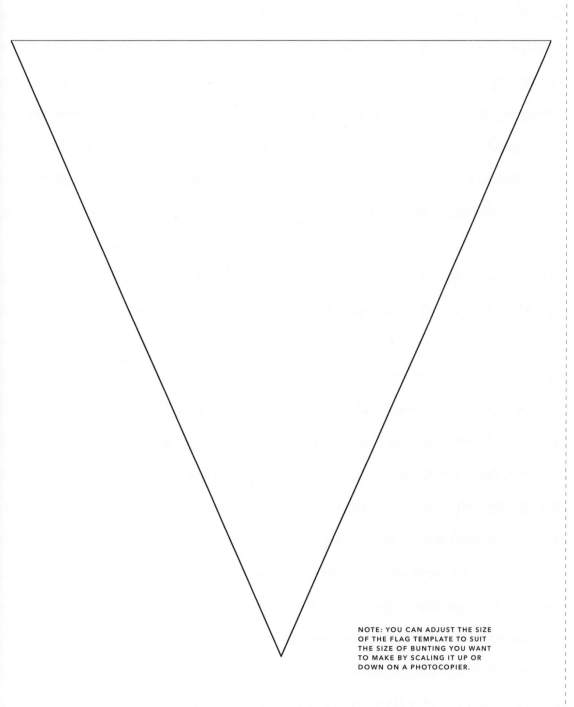

NOTE: YOU CAN ADJUST THE SIZE
OF THE FLAG TEMPLATE TO SUIT
THE SIZE OF BUNTING YOU WANT
TO MAKE BY SCALING IT UP OR
DOWN ON A PHOTOCOPIER.

Geometric garland

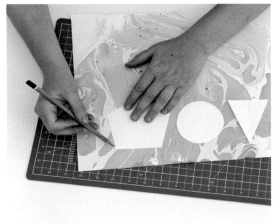

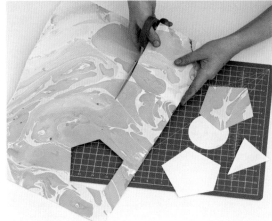

1. Draw the shapes Trace the templates opposite or photocopy them, transfer them to the card and cut them out. Draw around the templates onto the marbled paper. Make sure you have a good amount of each shape to work with.

2. Cutting out Cut the shapes out. If you want to have double-sided shapes, glue together pairs of the same type with right sides facing out.

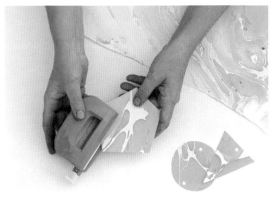

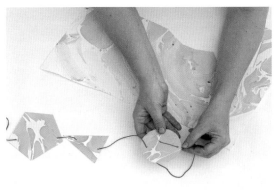

3. Make holes Using a hole punch, make two holes in each shape, on opposite sides.

4. Join them up Take a length of cord or string and thread it through each hole, working over and under each time. Keep going until you have the length required.

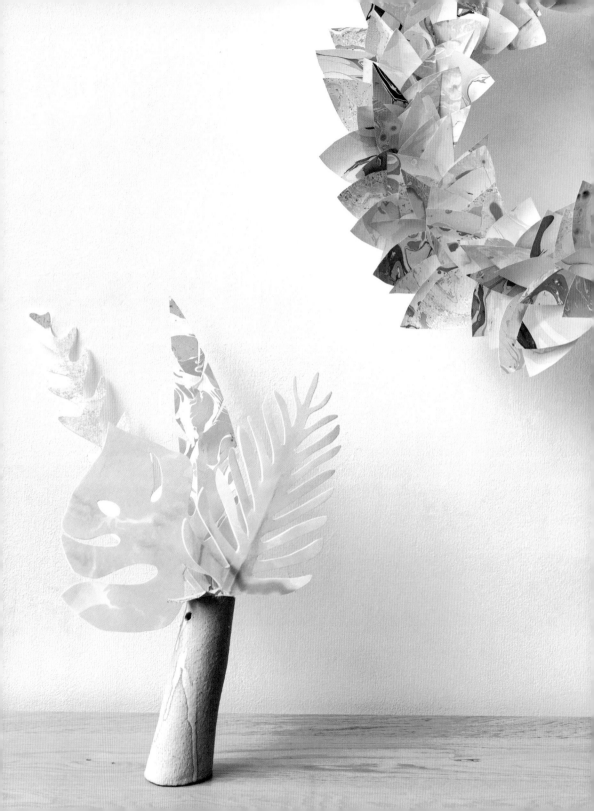

BOTANICAL CREATIONS

A striking, three-dimensional way of showcasing your marbling skills, these botanical-themed decorations are bold and unusual. The interesting mix of different marbled patterns and inks adds impact and texture.

The wired leaves can be made in whatever size you like by photocopying, scanning or photographing the templates on page 58–59 and adjusting them to a variety of sizes before printing. Over time, you can build up a collection in all different shapes and colours and eventually be rewarded with a colourful bouquet of sculpted leaves.

 The wreath, made up of smaller paper leaves, evolved from the larger wired leaves. I began making these pieces to use up my growing piles of marbled paper scraps as I didn't want them to go to waste. This wreath is a perfect way to display the small leaves for maximum impact; you will need quite a large quantity of them to fill the wire frame. Here, I used an 18in (46cm) wire wreath ring and used approximately 80–90 individual leaves.

 I have used all marbling ink types for the botanical projects. I love how the different characteristics of the inks adds another dimension to each individual leaf.

What you will need

Wired leaves

- Cutting mat
- Pencil and eraser
- Tracing paper
- Piece of card to make the templates
- A3 and A4 sheets of marbled paper in different patterns
- Scissors
- Pack of florist's wire
- Paper glue

Wreath

- Cutting mat
- Pencil and eraser
- Tracing paper
- Small piece of card to make the template
- Marbled paper in a few different patterns
- Scissors
- Craft knife
- Metal ruler
- Two-circle wire wreath ring (this one had a diameter of 18in/46cm)
- Hand-held stapler

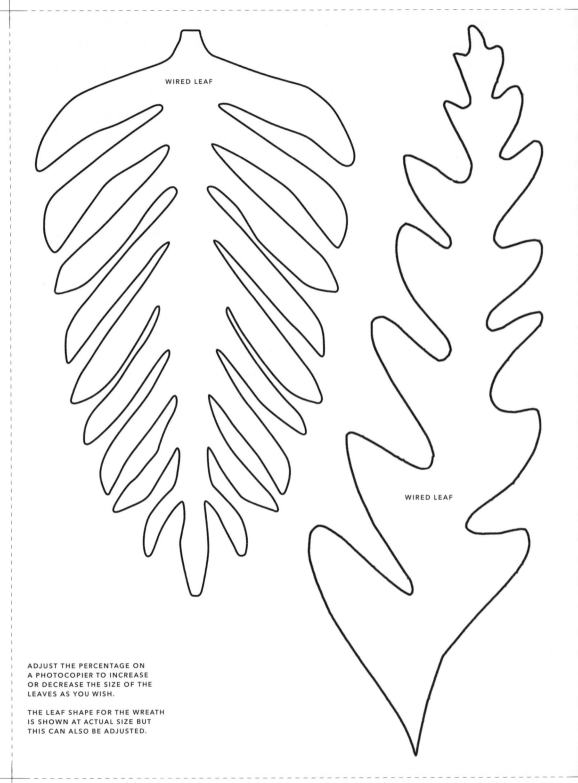

WIRED LEAF

WIRED LEAF

ADJUST THE PERCENTAGE ON
A PHOTOCOPIER TO INCREASE
OR DECREASE THE SIZE OF THE
LEAVES AS YOU WISH.

THE LEAF SHAPE FOR THE WREATH
IS SHOWN AT ACTUAL SIZE BUT
THIS CAN ALSO BE ADJUSTED.

WIRED LEAF

WIRED LEAF

SMALL LEAF FOR THE
WREATH: ACTUAL SIZE

Making the wired leaves

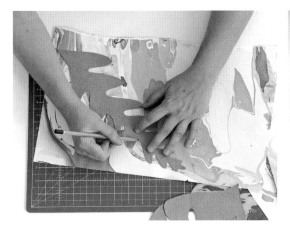

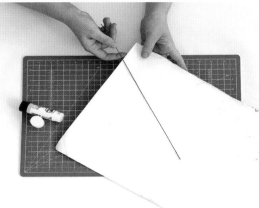

1. Choose a leaf Trace, scan, photograph or photocopy a leaf from the templates on pages 58–59 and transfer onto card to make a template. Draw around the template onto marbled paper but don't cut it out yet.

2. Position the wire Take another piece of marbled paper and cover it with paper glue on the unpatterned side. Lay a length of wire over the centre of the paper.

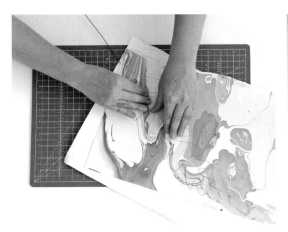

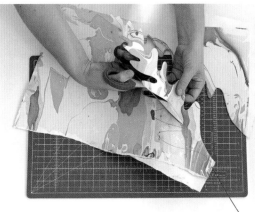

3. Sandwich the wire in place Take the sheet of paper with the leaf outline and place it on top of the glued paper. Position it so that the centreline of the leaf shape is lined up with the wire underneath. Feel through the paper with your fingers to manipulate it into the right place.

4. Cut out the leaf Cut out around the pencil outline of the leaf shape. If you like, you can bind the stems with spare offcuts of glued marbled paper.

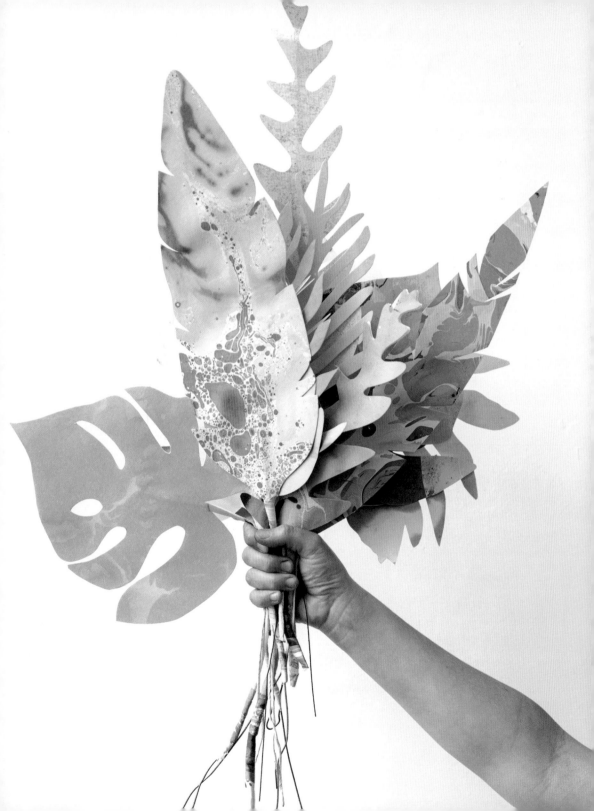

Assembling the wreath

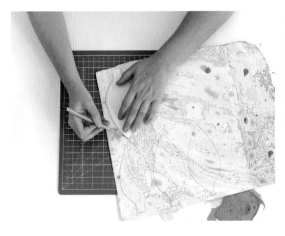

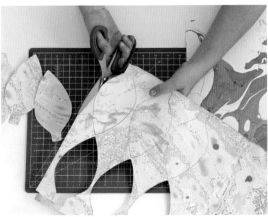

1. Draw around the leaves Trace around the leaf template on page 59, transfer it onto card and cut it out. Use it to draw around onto the marbled paper. You will need to make approximately 80–90 leaves for an 18in (46cm)-diameter wreath.

2. Cut the leaves Cut out the leaf shapes with scissors.

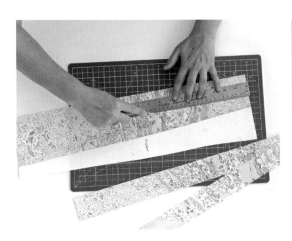

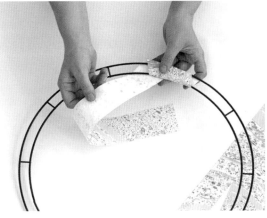

3. Slice some paper strips Use a craft knife and metal ruler to cut strips of spare marbled offcuts, about 2in (5cm) wide. The length can vary according to the offcuts you have available.

4. Bind the wreath frame Start wrapping the paper strips around the wire wreath frame. Wrap it over the same place a couple of times to hold. Work around gradually, covering up the wire as you go.

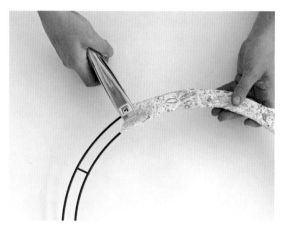

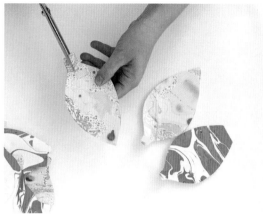

5. Securing the ends When you get to the end of a strip, secure it in place with a hand-held stapler before starting another one. Keep going until you have covered the whole frame.

6. Snip and pinch Take one of the leaf shapes and make a small cut at the centre of the stalk. Overlap the two flaps where the cut was made and pinch them together, giving a curved shape to the leaf. Repeat for all the leaves.

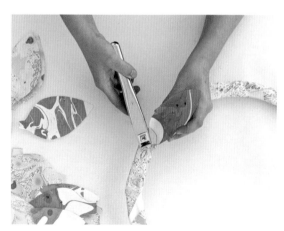

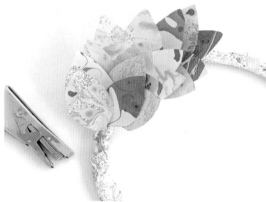

7. Attach the leaves Use the hand-held stapler to attach the leaves to the frame, keeping the pinched shape. If you have different patterns, mix them up randomly around the wreath.

8. Fill the frame Keep working around the ring, placing and stapling each leaf to create a pleasing shape. You can also slide the stalks into the folds of paper on the frame. Repeat until the whole frame is covered.

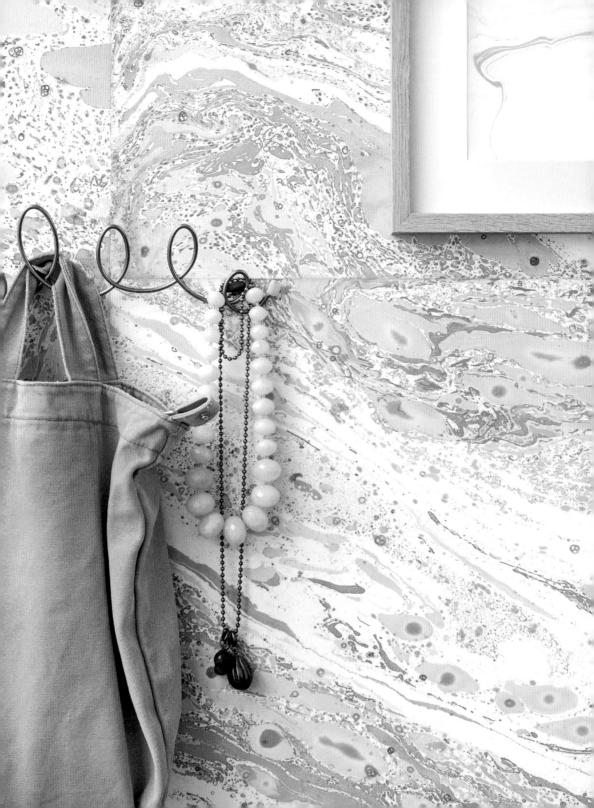

WALLPAPER

Creating your own wallpaper may seem daunting, but I would like to introduce you to an achievable and enjoyable way of making beautiful bespoke designs. Wallpapers originated in the 16th century and were first used to decorate the insides of cupboards and smaller rooms. They were printed in monochrome on small sheets of paper, and it wasn't until much later that these single sheets were joined together to form the long rolls that we know today. It is this traditional tiling technique that allows you to handle manageable paper sizes that will fit into a paddling pool for printing.

This project will be most suitable for decorating cupboards, small rooms and single walls. When assembling the sheets of marbled tiles, I like to place them on the floor to create the final composition. There is no right or wrong way to arrange them: it's an instinctive process to create a harmony between colour and pattern.

You can apply matt decorator's varnish to protect your wallpaper and make it more durable once installed, especially in high-traffic areas. It will also prevent the colours from fading, especially in areas with direct sunlight. The marbling ink used for this wallpaper is oil-based.

Tile size

Lining paper is available in rolls of different widths and lengths. The printed tiles that you hang will be trimmed squares that are determined by the width of your lining paper roll. For example, the width of the lining paper used on the following pages was 21in (54cm), so the tiles were trimmed to 21 x 21in (54 × 54cm) squares. Calculate roughly how many tiles you will need to cover the area you would like to cover. Allow for some extras as you may want to swap some in and out to create the finished composition.

What you will need

Printing

- Lining paper, pre-cut into lengths a little longer than your finished tile size (see box below)

- Marbling inks

- Padding pool

- String line and pegs for drying

Hanging the wallpaper

- Marbled lining paper pieces

- Cutting mat

- Long metal ruler

- Craft knife

- Pencil

- Adhesive putty

- Plumb line

- Stepladder

- Wallpaper adhesive ('paste the wall' type)

- Wide brush

- Wallpaper smoothing tool

- Kitchen paper

Printing the wallpaper

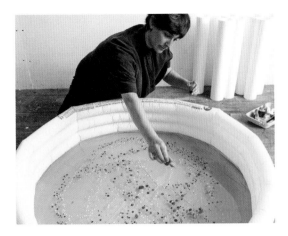

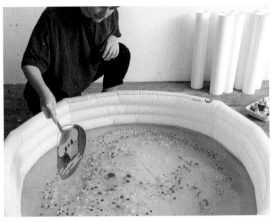

1. Set up Place the paddling pool in an area where you have enough space to work. Fill it about 2in (5cm) deep with tepid water. Have the pre-cut lining paper pieces and your chosen inks nearby. Start to apply the inks to the water.

2. Create patterns Move the inks around to create the effect you want. See pages 26–27 for more details about how to do this.

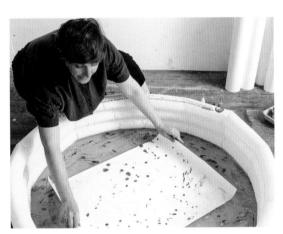

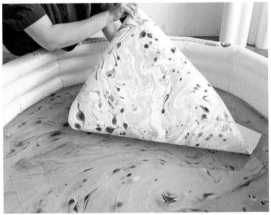

3. Print the paper Carefully lean over the pool and place the lining paper onto the water. Tap the paper to release any air bubbles.

4. Dry Peel away the paper to reveal your print and hang it up to dry. Keep using the same water and repeat Steps 2 and 3. To keep the colour and pattern consistent throughout your finished wall, I make two to three prints per print run, then re-ink the water. Flatten under a heavy object once they are damp.

Hanging the wallpaper

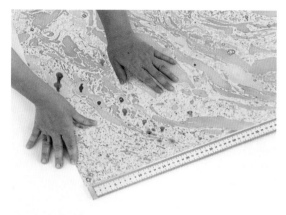

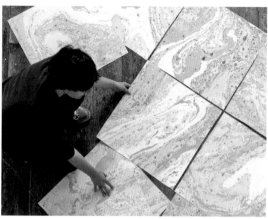

1. Trim into squares When the prints are dry, take the measurement from the width of the lining paper roll and use it to measure and trim square tiles of marbled paper (see box on page 65).

2. Arrange the tiles Make a composition on the floor of how you want the tiles to be ordered on the wall. Play around and create an overall pattern that you like. Take a snapshot for reference and number the back of each tile, also noting which is the top edge.

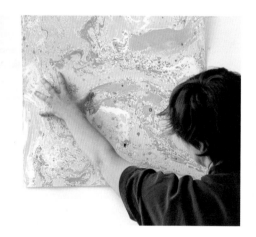

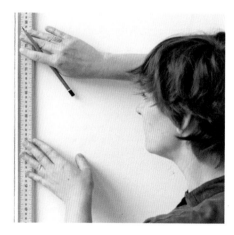

3. Position the first piece Roughly fix the first square to the wall with adhesive putty in the place where you need to place your first tile. Make a small pencil mark on the wall at the right edge of the tile. Allow about 2in (5cm) overlap at the top to trim later.

4. Draw a guideline Using a plumb line as a vertical guide and a long ruler, draw a light pencil line on the wall where you made the mark in Step 3. You now have a guideline to align the first tile to.

Hanging the wallpaper continued

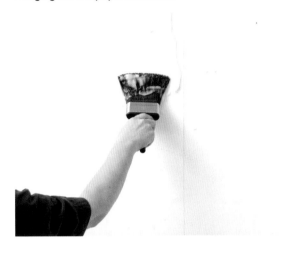

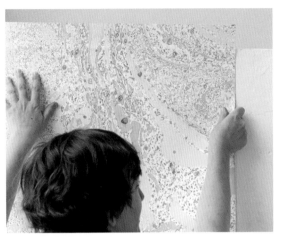

5. Paste the wall Apply wallpaper adhesive to the wall using a wide brush in the area of the first tile. Spread it thinly and evenly.

6. Place first tile Line up the right edge of the first tile with the pencil guideline, remembering to leave the overlap at the top edge.

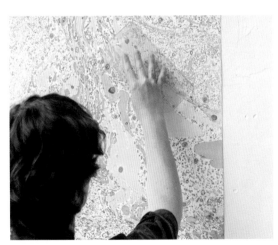

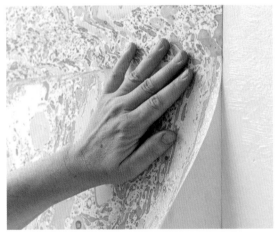

7. Smooth it out Smooth over it with the wallpaper smoothing tool to get rid of any air bubbles.

8. Line up next piece Working vertically, paste the wall underneath the first tile and then place it with edges butting up to the piece above and in alignment with the pencil guideline.

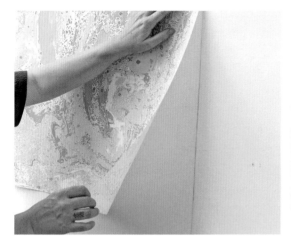

9. Place more tiles Continue working down the wall in this way. Leave an overlap of about 2in (5cm) at the bottom edge for trimming later.

10. Neaten the edges Clean up the joins between the tiles with the wallpaper smoothing tool and wipe off any excess glue that seeps out with some kitchen paper. Apply pressure to the joins to prevent them lifting.

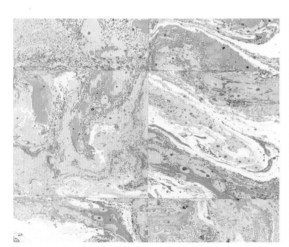

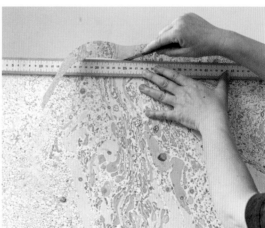

11. Cover the space Repeat the process until the whole area is covered. To start a new row of tiles, work from the top down each time, aligning the left edge with the previous row.

12. Trim excess paper at the bottom To finish, trim the excess paper fom the top and bottom edges with a long ruler and a craft knife.

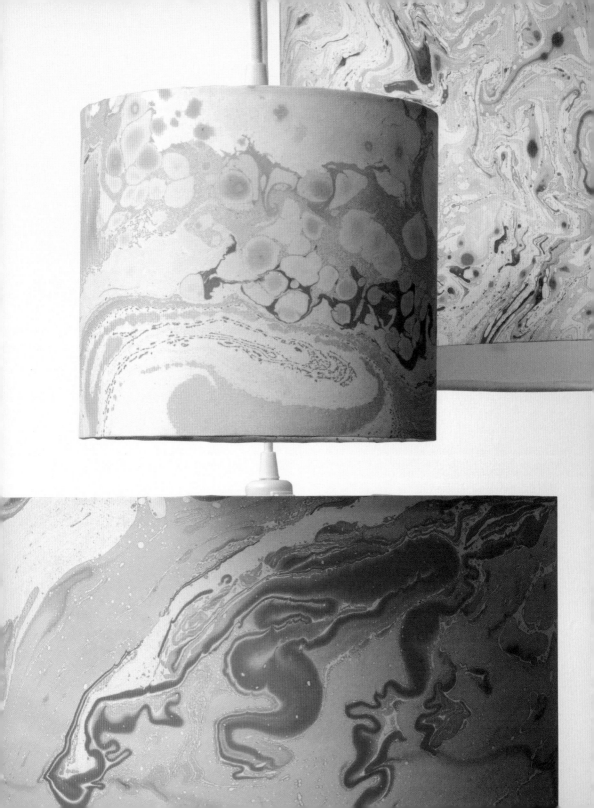

DRUM LAMPSHADE

Marbled patterns lend themselves particularly well to lampshades, creating a striking focal point in any room. The colour palette can be inspired by where the lampshade will be displayed, bringing the colours of the room together. The glow of the light will add another dimension to the marbling at night, creating a warm and soft ambience.

Lining paper is strong and works very well for lampshade making. Print it using the same method as for the wallpaper tiles (see page 66). The sheet will need to be large enough to cover the self-adhesive PVC panel in your lampshade kit. The marbling inks used here are oil-based.

 If you want to give an old drum lampshade a new covering then strip away the old PVC panel, leaving just the rings. If it comes away in one piece, you can use the old panel as a template for a new one. You can buy rolls of self-adhesive PVC backing and narrow double-sided sticky tape for lampshade making (see page 78 for suppliers). Some companies also offer a bespoke cutting service. Follow the same instructions on pages 72–74, missing out steps 4 and 5.

What you will need

- Drum lampshade kit (the one shown on pages 72–74 is 8in/20cm in diameter and 7in/18cm tall). See opposite if you want to upcycle an existing lampshade
- Sheet of marbled paper large enough to cover the PVC panel in your kit
- Scissors

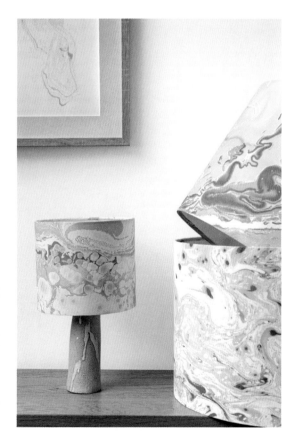

Safety
The self-adhesive PVC panels used in this project are heatproof and fire resistant. If you are attempting to make another style of lampshade or want to apply an inner lining, you may need to treat your materials with a fire-retardant spray. Leave a minimum of about 4in (10cm) between the shade and the lightbulb; it is sensible to use a 60-watt bulb, or less.

Making the lampshade

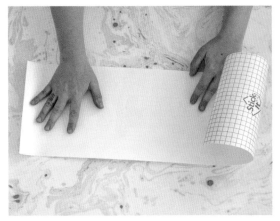

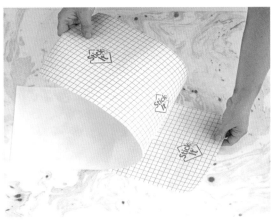

1. Position the PVC panel Place the sheet of marbled paper face down and position the PVC panel on the wrong side of the paper over the area of pattern you want. If you aren't using a kit, you will need to cut the PVC panel to size from your roll.

2. Stick down the panel Peel away the backing paper from one end of the PVC panel and gradually stick it down onto the back of the marbled paper, smoothing it as you go to prevent creases or bubbles.

3. Cut to size Trim around the edges of the PVC panel. If you are using a kit, the overlap will be built in to the panel already. If you are not using a kit, leave about ½in (1.5cm) of paper to overlap along each long edge and skip Steps 4 and 5.

4. Score the edges If you are using a kit, fold back the PVC panel along both long edges to score where the overlap will be.

5. Pull away the scored edges Remove the PVC along the scored edges, gently pulling it away. You will be left with a paper overlap on both the long edges of the panel.

6. Add tape Apply some double-sided sticky tape along one of the short sides of the panel. Don't remove the backing strip yet.

7. Add tape to the rings Evenly apply double-sided sticky tape around the outside edges of the two lampshade rings. Remove the backing strip.

8. Position the rings Carefully place the rings on each long edge of the PVC panel at the end opposite to where the tape is. They should be on the very edge of the plastic, not on the paper. Make sure that the struts are facing inwards.

Making the lampshade continued

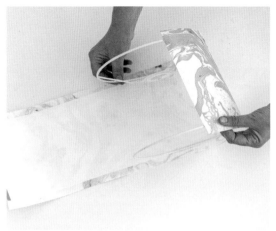

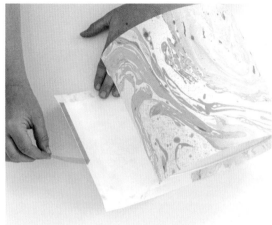

9. Rolling the rings Moving both rings at the same time, roll them along the panel, keeping them parallel to the edges. If you go off course, pull back a little and adjust.

10. Stick down the end When you are almost at the end, remove the backing strip from the tape on the short side of the panel and stick it down to secure the end of the panel in place. Press down from the inside to make sure it is firmly stuck.

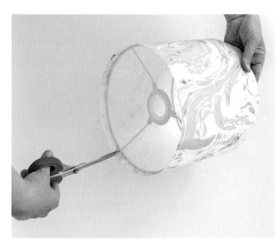

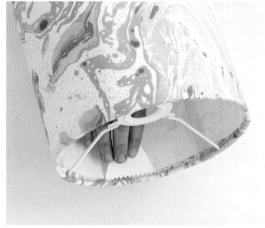

11. Make small cuts Using scissors, snip into the paper overlap where the struts are.

12. Neaten the overlap Roll the paper overlap over the sticky inner part of the rings on both sides. Use the finishing tool to poke the edge of the paper behind the rings. If not using a kit, use a bank card instead.

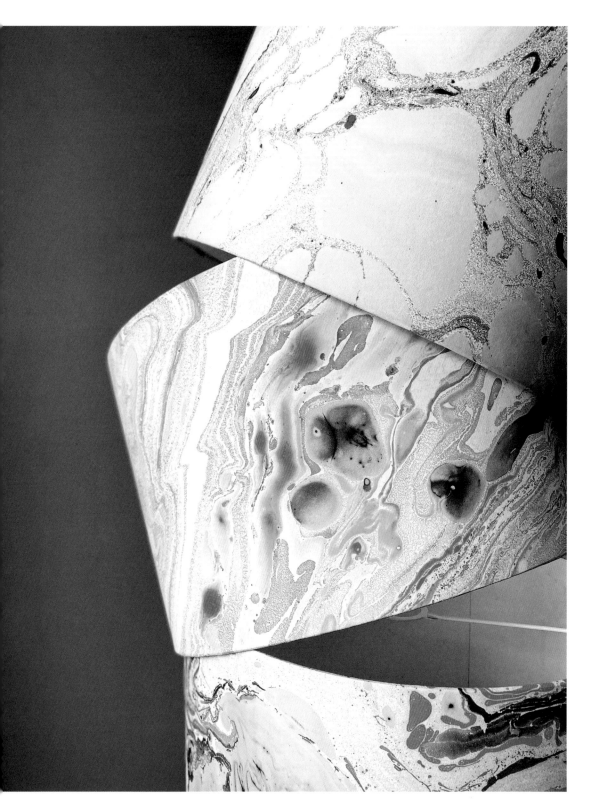

AFTERWORD

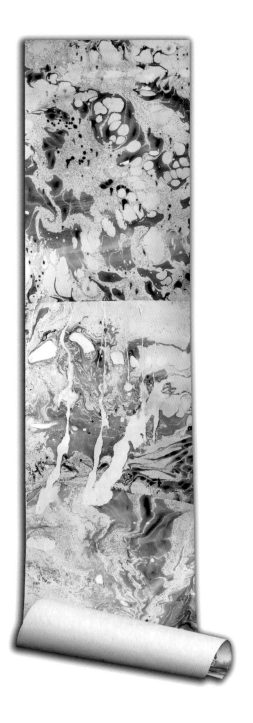

Continuing the marbling journey

My creations are a fusion of traditional techniques and a modern aesthetic. Drawing inspiration from the rich legacy of *suminagashi*, each print tells a story of vibrant colours, mesmerising patterns and the interplay between fluidity and intention. I want to make sure that this type of marbling remains current and fresh, admired not just for its historical significance but also for its relevance, blurring the traditional boundaries of craft and art.

Many of my marbling commissions are a collaborative process with the client. I am often given a specific brief which enables me to expand the boundaries of my marbling techniques and colour palettes. Through these projects I have not only created wall pieces but also kitchen splashbacks, set pieces for photoshoots, 3D paper installations, branding and an artistic collaboration of bespoke abstract marble and ink designs transformed into a collection of exclusive hand-knotted rugs.

The organic process of *suminagashi* marbling constantly opens up new possibilities for creating new techniques and outcomes. That's why I love marbling: it is a deeply instinctive craft which can be accessed by all levels of ability. It can unlock your creative side or expand an already existing creative path.

I hope this book will give you mindful moments of delving into a magical craft, allow you to create fun marbling sessions with family members or simply create colourful pieces for your home to enjoy. It's the journey that is the beauty, the outcome is a wonderful bonus.

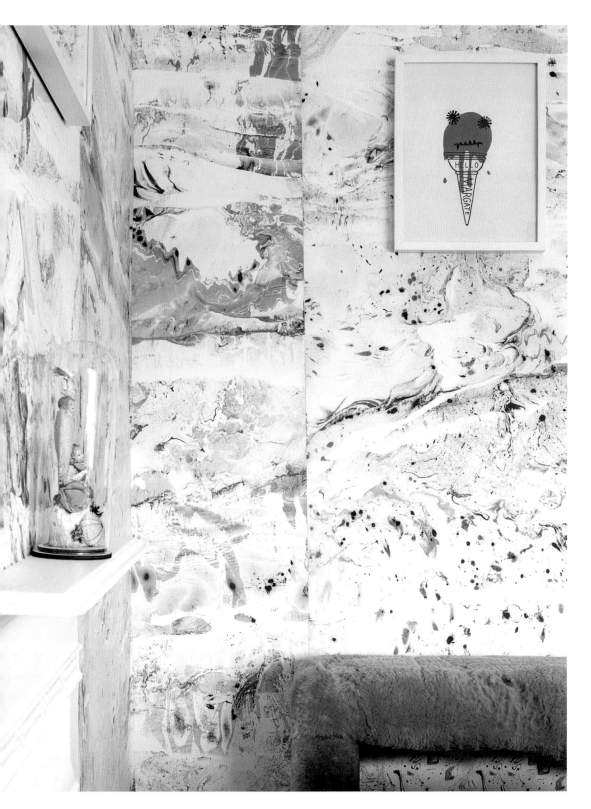

Suppliers

Marbling inks

Baker Ross: bakerross.co.uk
London Graphics Centre: londongraphics.co.uk
Jackson's Art: jacksonsart.com
Cass Art: cassart.co.uk

Paper

Eco Craft: eco-craft.co.uk
Khadi Paper: khadi.com
Cass Art: cassart.co.uk

Lampshade-making supplies

Dannells: dannells.com
Fred Aldous: fredaldous.co.uk

Wallpaper supplies

Celtic Sustainables: celticsustainables.co.uk
Brewers: brewers.co.uk

Paper marbling kits

Natmaks: natmaks.com

Art, craft and interiors inspiration

The Jealous Curator: thejealouscurator.com
Dezeen: dezeen.com
Design Milk: design-milk.com
Hole & Corner: holeandcorner.com
Kinfolk: kinfolk.com

About the author

Natascha Maksimovic is a designer, artist and wallpaper-maker based in Margate, Kent, where she practises the time-honoured art form of *suminagashi* paper marbling. Having previously worked as a designer in the film industry alongside Sir Ridley Scott, Natascha decided to set up her own studio to explore both craftsmanship and collaboration, and her bespoke wallpapers have since featured in *Elle Decoration*, *Living Etc*, the *Guardian*, the *Sunday Times* and the *Daily Telegraph*.

natmaks.com
Follow on Instagram: @natmaks

Acknowledgements

I would like to thank my husband Jolyon for his unwavering support and my children Melody and Sonny for encouraging me to always be curious. Huge thanks to Zara for giving me this incredible opportunity and Virginia for guiding me all the way. Danke an meine Eltern Petra und Ivica, die meine kreative Reise ermöglicht haben.

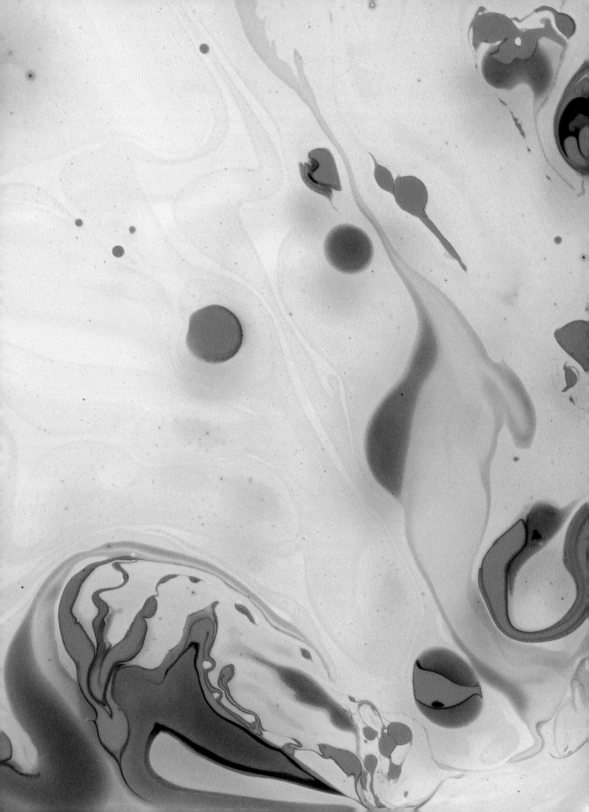

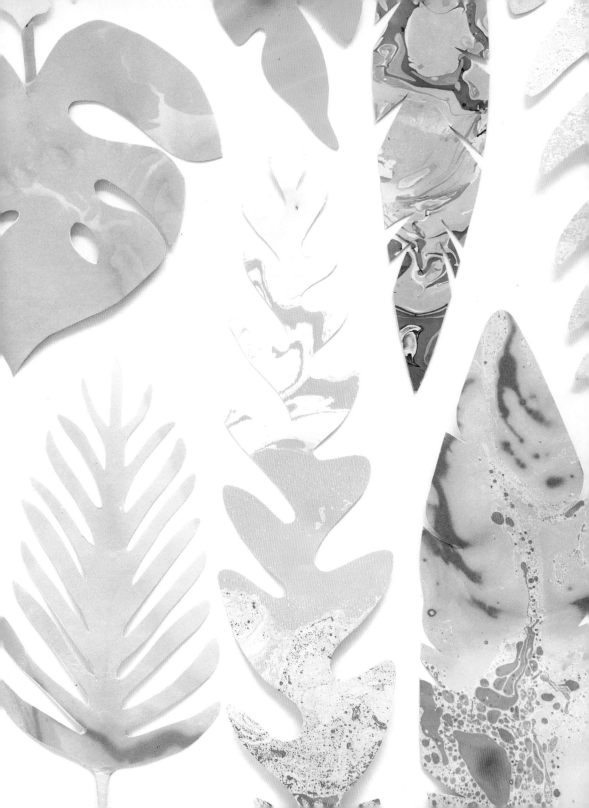